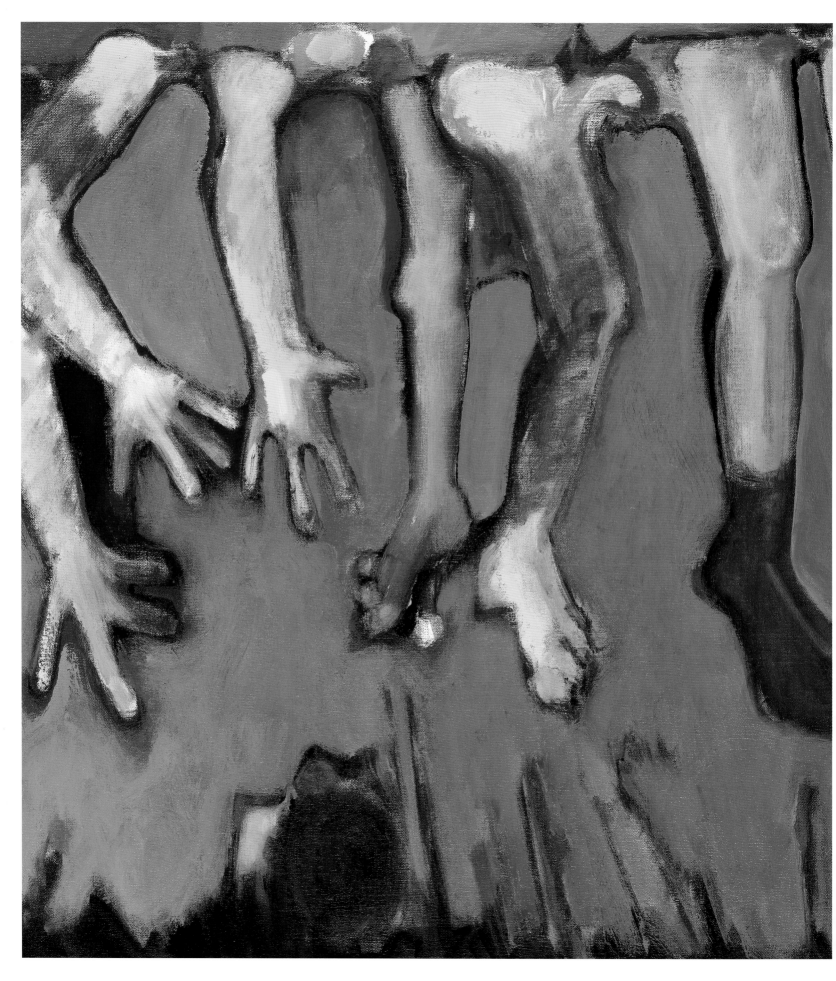

Ransoming Mathew Brady

paintings by John Ransom Phillips

Mathew Brady Ransomed

essay by Alan Trachtenberg

Clarissa Editions
New York

★

In association with Hudson Hills Press
Manchester and New York

Published in association with Hudson Hills Press LLC
3556 Main Street, Manchester, Vermont 05254

Distributed in the United States, its territories and possessions, and
Canada by National Book Network, Inc. Distributed outside North
America by Antique Collectors' Club, Ltd.

Library of Congress Cataloging-in-Publication Data
Phillips, John
 Ransoming Mathew Brady / paintings by John Ransom Phillips.
 Mathew Brady ransomed / essay by Alan Trachtenberg.
 p. cm.
 Added t.p. title: Mathew Brady ransomed
 ISBN: 978-1-55595-326-3 (hardcover)
 1. Phillips, John. 2. Brady, Mathew B., 1823 (ca.)–1896—Influence.
 I. Trachtenberg, Alan. Mathew Brady ransomed. II. Title. III. Title:
 Mathew Brady ransomed.
 ND237.P47235A4 2009
 759.13—dc22 2009036798

Cover: *Photographing You*, 2006, oil on canvas, 28 × 26 inches
Title page: *Death and Forgotten Selves at Second Manassas (August 30, 1862)* [detail], 2007, oil on canvas, 40 × 50 inches
Endpapers: Unidentified man, head-and-shoulders portrait, facing front. Library of Congress.

All watercolors: 2003–07, on paper, 22 × 15 inches

Publisher and Executive Director: Leslie Pell van Breen
Founding Publisher: Paul Anbinder
Producer: Nikolaje DeVrsac
Designer: Caroline Jerome
Editor: Sharon Rutberg
Color management by iocolor, Seattle
Produced by Marquand Books, Inc., Seattle, www.marquand.com
Printed and bound in China by Artron Color Printing, Ltd.

www.johnransomphillips.com

clarissa
editions

John Ransom Phillips gratefully acknowledges Karl Leichum and Cyndi Dale,
long-time collectors of his work, whose invaluable assistance—both material and spiritual—
made possible the series of paintings on Mathew Brady and this book.

★

Alan Trachtenberg thanks Leo Marx for his generous reading
of the essay and Betty Trachtenberg for her indispensable support throughout.

Mathew Brady Ransomed

by Alan Trachtenberg

the United States themselves
are essentially the greatest
poem

To Begin

―•·•―

"a strange, unloosen'd, wondrous time"
—Walt Whitman

Ransoming Mathew Brady tells a story at once sensuous and cerebral, esoteric yet enticing. An intellectual discourse in paint and words, this extraordinary cumulative work by John Ransom Phillips fits no existing genre, though history painting is a close fit. With some fifty paintings in oil, about two hundred watercolors, and an array of tantalizing words in titles of paintings, sayings, and prose poems inscribed by hand on many of the watercolors, it is an essay on history, on vision and blindness, on violence, on color and space, on death and rebirth. *Ransoming Mathew Brady* asks from its viewers and readers not only eyes wide open but a willingness to take on such immensity. The intimacy of the paintings and the choreography of hues and shapes keep the ensemble in constant ferment. An encyclopedic undertaking, *Ransoming* leaves nothing untouched. A strenuous work of interrelated parts, it calls for a strenuous response.

Ransoming Mathew Brady offers a discourse on America, on *ideas* of the nation. "America" underlay Mathew Brady's career as a portrait photographer before the Civil War and then drove him to depict that savage war as national history.[1] As a portraitist Brady identified America with the success of its most prominent citizens, those he portrayed as "Illustrious Americans." The self-made man and woman, the ease of achieving fame, success, and celebrity, seemed the nation's fundamental justification in the eyes of Brady and other portrait photographers at the time. This was an idea of America that flourished in the new antebellum photographic portrait studios, of which Brady's on Broadway in New York was the most famous in the land.

With the outbreak of the Civil War in 1861 Brady at once shifted gears. He brought his studio to the battlefield, not only the photographic apparatus, now bundled into clumsy field wagons that doubled as darkrooms, but also the assumptions and values of portrait-making. Most of Brady's pictures from the war years remain portraits, though adapted to new conditions: open-air portraits, often officers sitting in semi-formal pose; groups of soldiers informally gathered in camp; or men arrayed around a battery of heavy weapons. The greatest challenge to the studio system and its values lay on the ground in the aftermath of battles, the fresh corpses that defied *portraiture* but could only be transformed into *images* where they fell. Battlefield scenes mocked and subverted the notion of celebrity that Brady had earlier so powerfully associated with

[opposite]
*the United States themselves
are essentially the greatest
poem.*

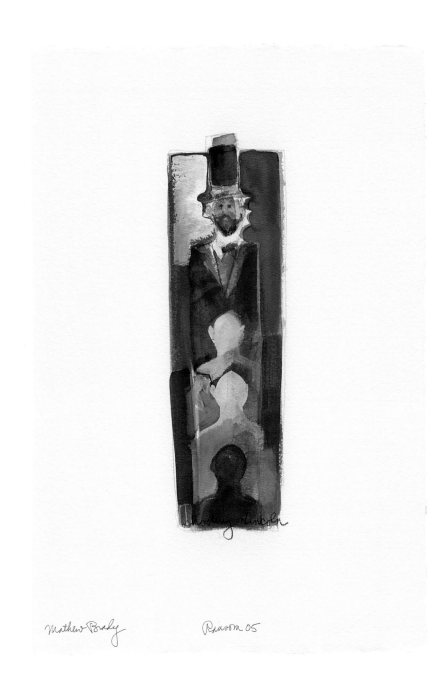

Mathew Brady Ransom 05

shooting Lincoln

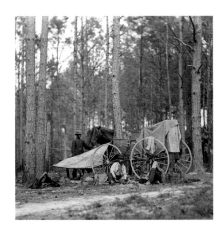

the idea of America. No wonder that Brady himself turned away from scenes of carnage and violent death. He could not bear the sight.

During the war Brady embraced the idea of America as Union, especially as represented by the man whose face his studio had helped make the most photographed face in the land, that of Abraham Lincoln. Lincoln's face circulated everywhere, among friends and foes alike but especially among emancipated blacks, as the most potent visual symbol and promise of a unified America restored to freedom and equality. For Walt Whitman, who knew Brady and was photographed by him on several occasions, America had always stood for democracy, with emphasis on equality, a different emphasis (though not totally so) from Brady's emphasis on opportunities for personal fame and illustriousness.[2] It was this, the conversion of the portrait studio into an atelier for the crafting of "celebrity," that earned Brady his own fame, wealth, and celebrity before the war. These different visions of America are all at stake in the enterprise of "ransoming" Mathew Brady. "I created an unlimited number of images from the same negative," Phillips has Brady explain in a reflection scrawled on one of the watercolors, "with America as subject" (p. 5)—an epochal subject that cannot be evaded, as *Ransoming Mathew Brady* shows in its illuminating, many-hued analysis.

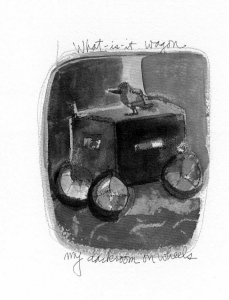

*What-is-it wagon
my darkroom on wheels*

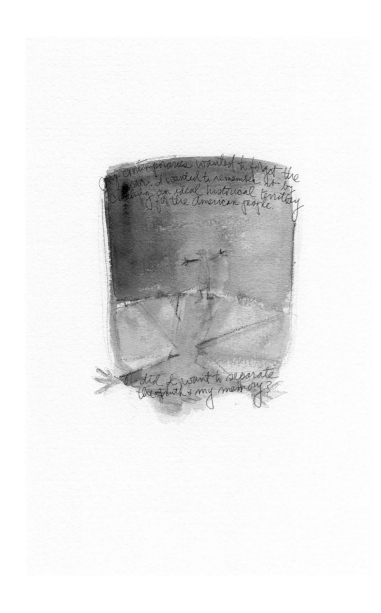

While not exactly a series in fixed sequence, the work has a chronological base: it covers the antebellum years, the 1840s and 1850s, to the years of civil war, the early 1860s. But it is also a work of our own time; its story is not "of the past" as such but of the *act* of looking back and living past lives now. There is history in Phillips's paintings, elements of a narrated past, and there is temporality, the *experience* of time passing. There is Brady's personal history and the history of his era, one private, the other public. A true biographer and historian, Phillips recognizes that one cannot be understood apart from the other. He shows Mathew Brady both as himself, *sui generis*, and as representative of his age. Just as Brady conducted his portrait business with an eye to history, so in his wartime project the destiny of the *nation* as both idea and political entity emerged as his largest subject. Other photographers had similar intentions.[3] Brady's special gift was to be in the right place at the right time.

There has perhaps never been anything quite like *Ransoming Mathew Brady* in the genre of history painting. It covers the antebellum and war years by uncovering patterns, issues, textures, and timbres of the times, not in naturalistic detail but realistically nevertheless. The mode of the work is allusive, compounded of colorist expressionism, surrealism, abstraction, pop art, and elements of cubism.[4] But while the work alludes to or avails itself of stylistic elements from the history of painting, especially twentieth-century painting, it does so without abandoning anything of itself: its own integrity, its own realism, what is true to the artist's personal insight, knowledge, and feeling.

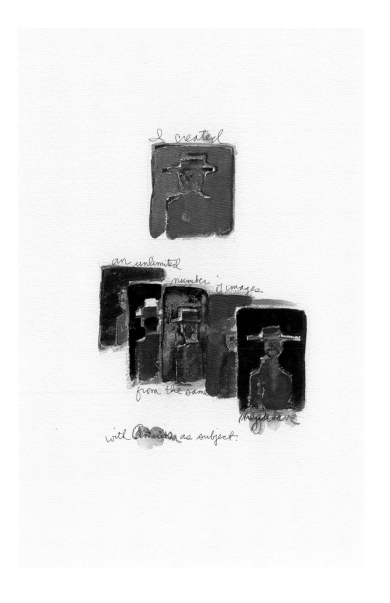

At the center is the figure called Mathew Brady, looking like a comic strip American Everyman. Phillips grasps what it must have taken the artist to invent himself as "Mathew Brady," the genius of the early studio era of photography, and then to show the way ahead by taking the camera out of doors, into the *plein air* of Civil War battlefields (although he rarely dared cast his eyes on them). Being Mathew Brady was no easy piece of work; half-blind from childhood, Brady, the one-eyed, straw-hatted *artiste* who strived to represent America to itself, became the recording angel of the nation in its throes of civil war. Phillips's Brady is something like Melville's "original" (Melville's word) character in *The Confidence-Man*: "like a revolving Drummond light, raying away from itself all around it—everything is lit by it, everything starts up to it."[5] Like Melville's novel, *Ransoming Mathew Brady* combines satire and prophecy to frame a scorching vision of this troubling era. Brady's career, its triumphs and its pathos, sheds raking light on the masquerades and self-deceptions that seemed to drag the nation over the edge into horrific civil war.

Phillips is concerned with the price Brady paid for his success, the same fame and celebrity he so lavishly bestowed on others by means of his camera. As a representative figure of his time Brady belongs to its "inside narrative," the untold cultural memory of the nation's near-fatal identity crisis in the 1850s and 1860s. His story illuminates history still being lived in the United States.[6] The power of *Ransoming* lies in Phillips's uncanny grasp of the ambiguities of Mathew Brady, of photography itself, and of their role in the mythic history of the nation.

*I created
an unlimited
number of images
from the same
negative
with America as subject.*

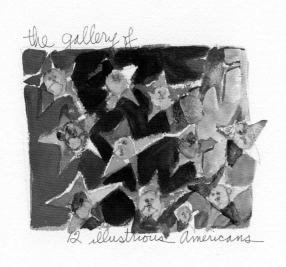

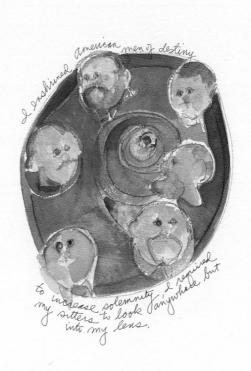

the gallery of
12 illustrious Americans

I enshrined American men of destiny
to increase solemnity, I required
my sitters to look anywhere but
into my lens.

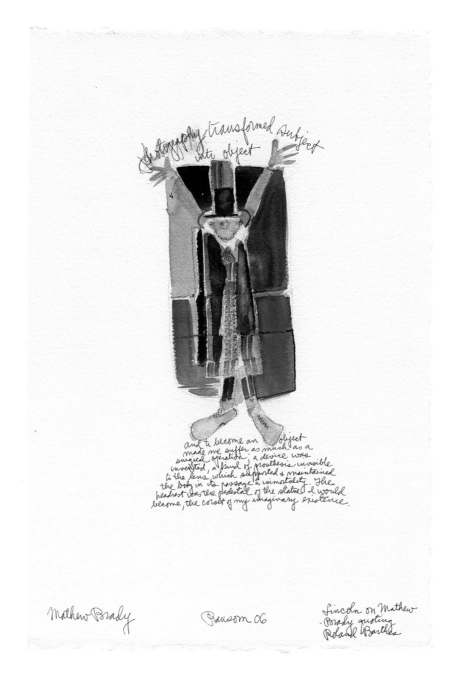

photography transformed subject
into object
and to become an object
made me suffer as much as a
surgical operation; a device was
invented, a kind of prosthesis invisible
to the lens, which supported and maintained
the body in its passage to immortality. The
headrest was the pedestal of the statue I would
become, the corset of my imaginary existence.

Lincoln on Mathew
Brady quoting
Roland Barthes

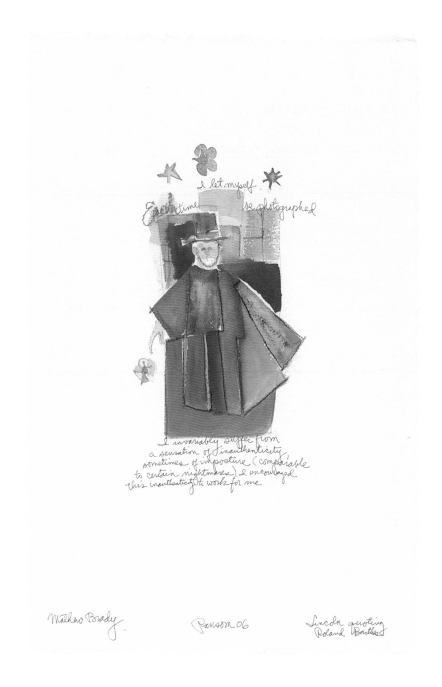

Mathew Brady Ransom 06 Lincoln quoting
 Roland Barthes

Each time I let myself be photographed
I invariably suffer from
a sensation of inauthenticity,
sometimes of imposture (comparable
to certain nightmares). I encouraged
this inauthenticity to work for me

Lincoln quoting
Roland Barthes

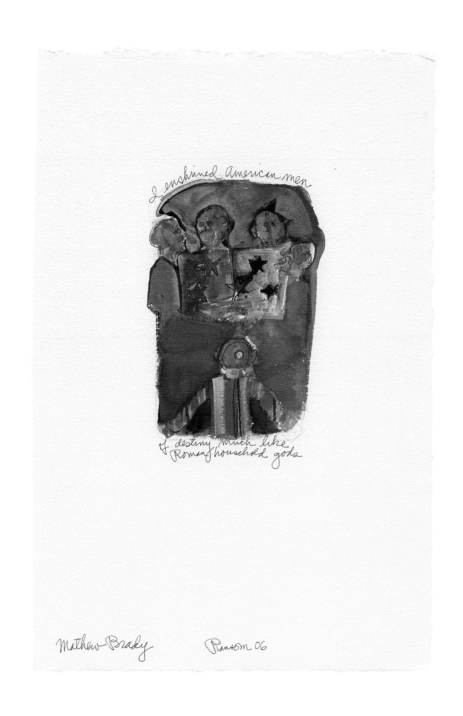

I enshrined American men
of destiny much like
Roman household gods

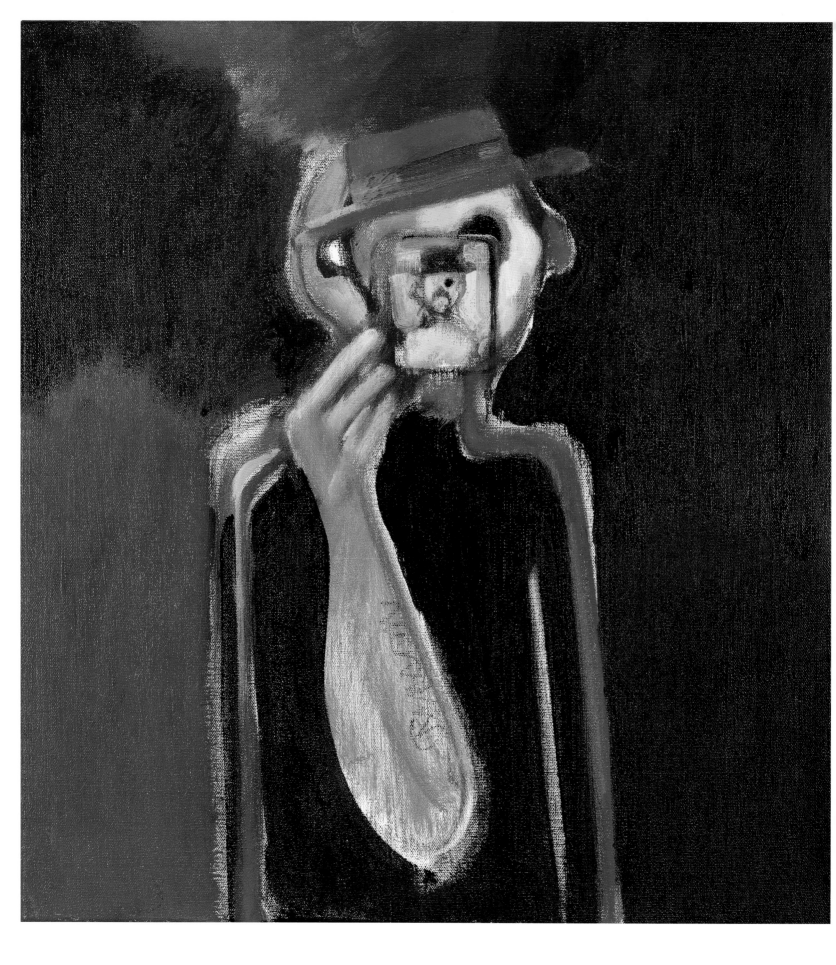

Photographing You in the Image of Me

If there is a single image that encapsulates *Ransoming Mathew Brady* it is *Photographing You* (opposite page). Take it as the inaugural act, an invitation, and dare to accept the role of Brady's "you." The picture prepares the role. Brady reaches out through his camera to "you," not a specific sitter with a name and a distinctive and perhaps familiar physiognomy, like Lincoln or Whitman or Brady himself, but the general, abstract, universal, democratic "you," the addressee of all addresses, the second-person pronoun that embraces all "you" into an undifferentiated collectivity. "You" comprises any audience, anyone that listens, that hears, that looks: the "you" of Whitman's "what I assume you shall assume, For every atom belonging to me as good belongs to you."[7] It is the "you" that defines by opposition the "me" of any linguistic discourse. It is the "you" by which "Brady of Broadway," portraitist, apprehends, denies, and knows himself in a single act, the "you" which stands or falls as Brady's self-knowledge. He *is* insofar as he is "photographing *you*," a process never ending, always unfinished.

Photographing You: think of it as posted at street-level by the staircase to the studio, the place where every imaginable "you" has a chance to emerge as an image, not only imaginable but already imagined, already imaged in and by the camera. The picture advertises; it invites and dedicates. It shows that this is indeed Mathew Brady. The flat jaunty hat gives him away; it is red here, though elsewhere (also in the same painting) it is black and in other places yellow. The blackness—a pirate's patch?—over the left eye

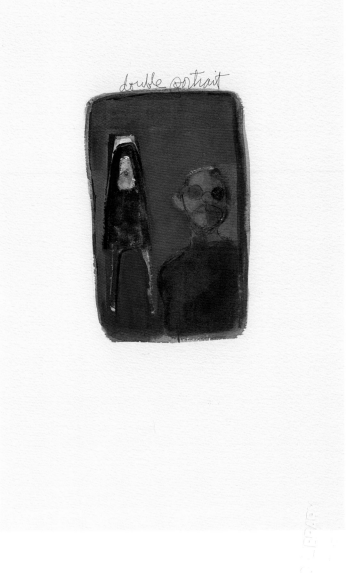

double portrait

[opposite]
Photographing You, 2006
oil on canvas, 28 × 26 inches

I made more than a picture

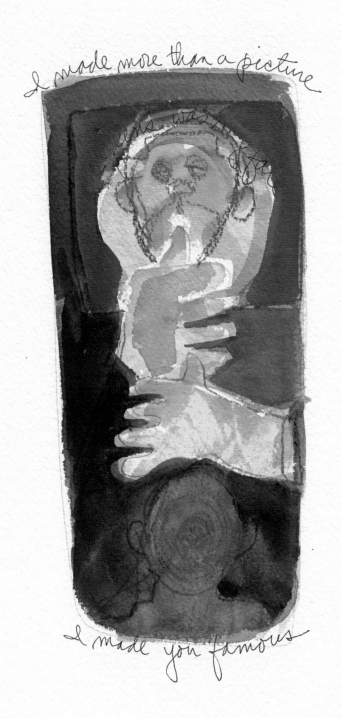

I made you famous

is another giveaway, calling attention to Brady's famously weak left eye, the lazy eye, the sinister eye, the eye that sees not enough and too much and cannot always tell the difference. And looking into the lens—the rectangle obscuring (obliterating?) all features of the face but for about half of the black left eye—what do you see and apprehend but the very image of the operator himself, the entrepreneur and proprietor, Brady of Broadway, the unobstructed face, notorious left eye a deep black hole, right eye a nothingness, mustachio and beard, jaunty red hat now black? Or was it always black, only red provisionally on the figure holding the camera, an artifact of our seeing, the painter's way made into our own for that moment, not how things "really are" but how they seem to be seen? And that is already a lesson at the threshold of the studio's ways of seeing. The pedagogy continues with the realization that expecting to see *ourselves* in the mirror of the protruding lens, we see instead an image of the photographer! Does the upside-down sensation that the lens produces register an inverted world? In a related watercolor Phillips has Brady cajole all knowingly, "my lens was my face and I could celebrate your face as a symbol of success—sit for me" (p. 17).

There is an important logic in this image of the doubled face, another pedagogical clue laid down. Produced with greater speed, as the artist's body bends over the shimmering wet surface that dries very quickly but meanwhile feels alive, watercolors function in the Phillips ensemble to explicate and to comment on aspects of the more discursive oils with their internal dialogue of signifying colors. Together

my left eye

[opposite]
I made more than a picture
I made you famous

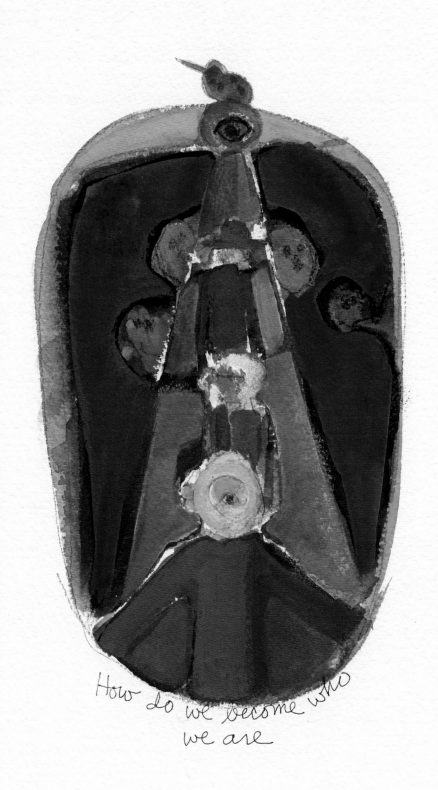

How do we become who we are

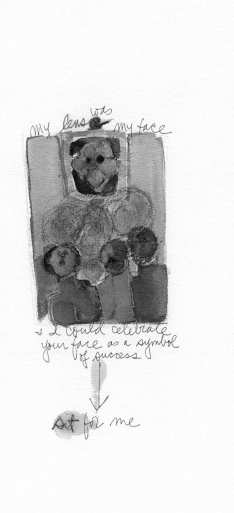

with related watercolors, *Photographing You* asks: What is a photographic portrait? How does it come about? Is it no more than a transcription of a face, details of underlying bone structure traced by an epidermal surface?

In *Photographing You* the portrayal seems already present on the outside of the lens. Has something already happened prior to the "photographing" of "you"? A related watercolor asks: "How do we become who we are?" Here, the little bird at the top reminds us that potential selves include past selves; in Egyptian hieroglyphics this bird stands for Osiris, who represents death and rebirth, the condition of always-coming-back-to-life. The studio is theatre, certainly, and sitters perform themselves as they are given to believe themselves to be—the image of Brady himself on the front of his lens in *Photographing You*. Are portraits copies or projections or partly both? Is a Brady portrait, then, not *you* but a copy of someone impersonating an idea of you?

Pedagogy continues with further consideration of the inaugural painting. Is that a body Brady inhabits, or a shell, or several shells dovetailed together, each a different color juxtaposed to the central black, out of which that strangely muscular arm and elbow emerge as if a preternatural object, a phantasmagoria? Another watercolor shows a possibly detachable right arm, *my right hand never went to sleep* (p. 19), while *Photographing was an act of theater* (p. 18) shows the detached right arm of a director waving in space. Blackness such as that of the torso in

*my lens was my face
and I could celebrate
your face as a symbol
of success —
sit for me*

[opposite]
*How do we become who
we are*

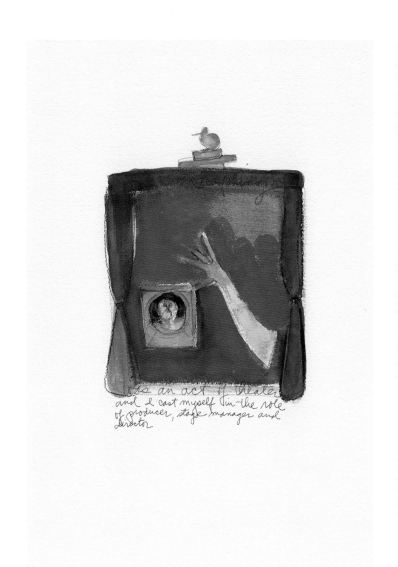

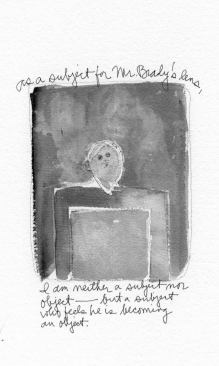

*Photographing
was an act of theater
and I cast myself in the role
of producer, stage manager and
director*

*as a subject for Mr. Brady's lens,
I am neither a subject nor
object—but a subject
who feels he is becoming
an object.*

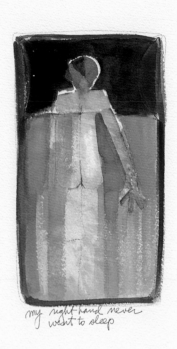

my right hand never went to sleep

Photographing You recurs throughout *Ransoming Mathew Brady*. Is it a sign of that "power of blackness" that taunted Poe and Hawthorne and Melville, also Whitman in certain moods, artists of the epoch to which Phillips feels special kinship, the mid-century era that produced great visionary art and devastating civil war in the same moment?[8] Is the arm emerging from the pit of blackness an optical illusion, a spectre, a premonition? We will confront disembodied limbs again in Phillips's unflinching oil paintings of Civil War battlefields. Does the reified arm imply that the rest of the body has shriveled into fleshless blackness, perhaps repressed, perhaps punished?

Photographing You prods us to ask: Was Mathew Brady, then, a one-eyed ogre with a detachable arm? Is this the way he truly was, how he looked to others? Or is it the way he saw and felt himself to be, how he imagined himself, a ghostly self with a heart of darkness? Of course this is Phillips's Brady projected into the fictive space of the canvas. The painting objectifies the subjective in an ironic version of Brady's own work as portraitist. "As a subject for Mr. Brady's lens," we hear in the voice of another watercolor, "I am neither a subject nor object—but a subject who feels he is becoming an object" (opposite page, right). In another twist we might ask whether the black tunic is not actually the dark cloth under which the operator captures the image, a metonymic trope for the black interior of the camera box from which issues the light-picture, the photographic image as Brady imagined it, lustrous with

my right hand never went to sleep

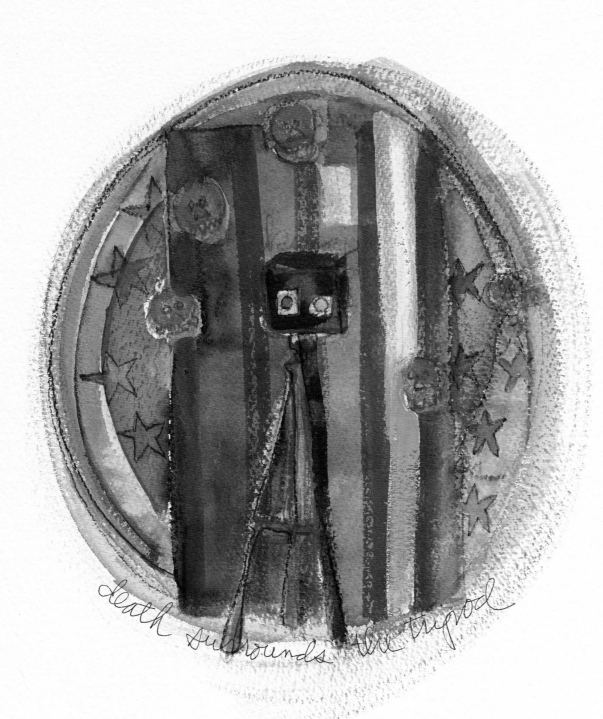

death surrounds the tripod

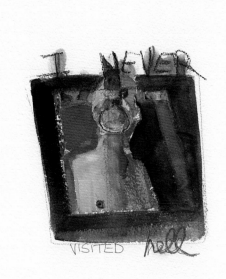

fame and celebrity. The camera makes palpable the foundational illusion of Brady's project: a body infused with identity, a knowable self, a "you."

Or is it a self *already* known, a predetermined self? *Photographing You* exposes a certain tautology at the base of American individualism. Brady's face on the face of his lens remakes his subjects into replicas of himself, objects for his devouring lens, dead souls. The national solipsism known as "individualism" would soon take its toll on fields of uncivil slaughter and massacre, toward which the all-seeing but self-blinded Brady could only aim his camera (that is, his cameras-in-the-field operated by others) and avert his face. Even before the war the dead had already piled up around him, Phillips suggests in *Death Surrounds My Camera* (p. 92), *Shooting the Dead* (pp. 22–23), and *Gallery of Dead* (p. 25). *Heaven: Mathew Brady Embraces the Underworld* (p. 45) clinches the view that Brady of Broadway drained life from his sitters, that like Tiresias he visited the Underworld but unlike his mythic counterpart, the blind seer, he descended all unknowingly. In another watercolor Phillips has him confide that he never visited Hell (this page). Is the unransomed Mathew Brady blind to whether he is among the living or the dead?

I NEVER
VISITED hell

[opposite]
death surrounds the tripod

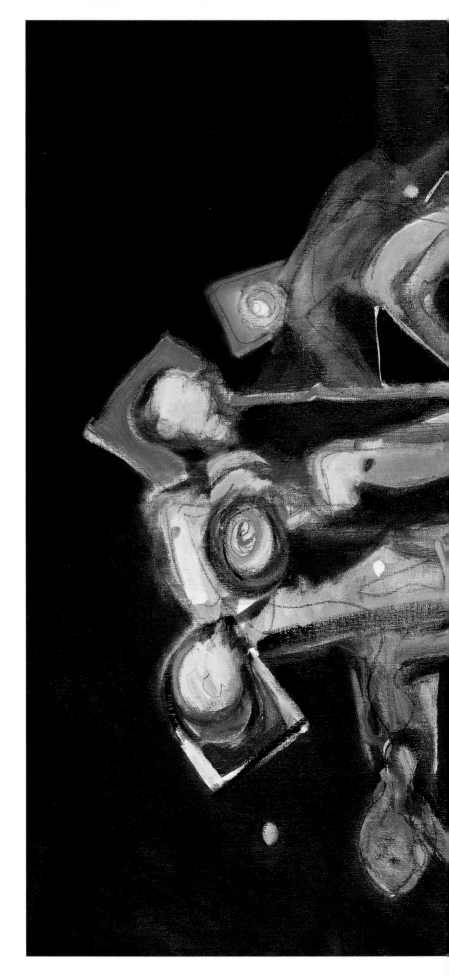

Shooting the Dead, 2005
oil on canvas, 50 × 70 inches

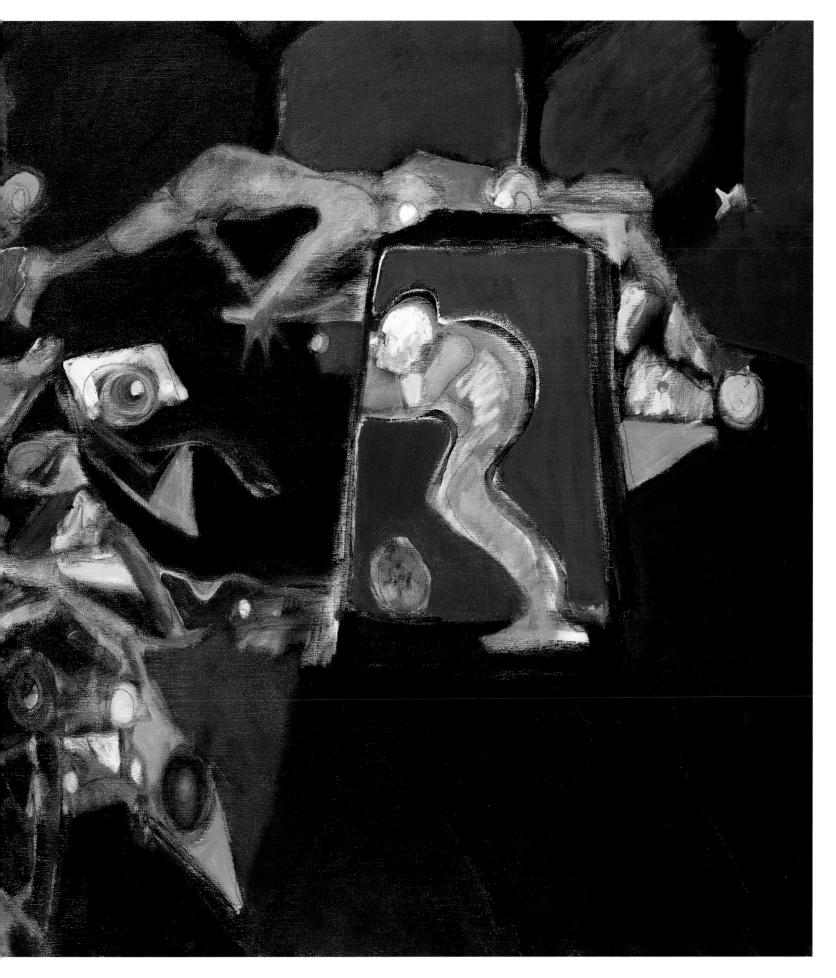

Gallery of Dead (2 panels), 2005
oil on canvas, 33 × 33 inches

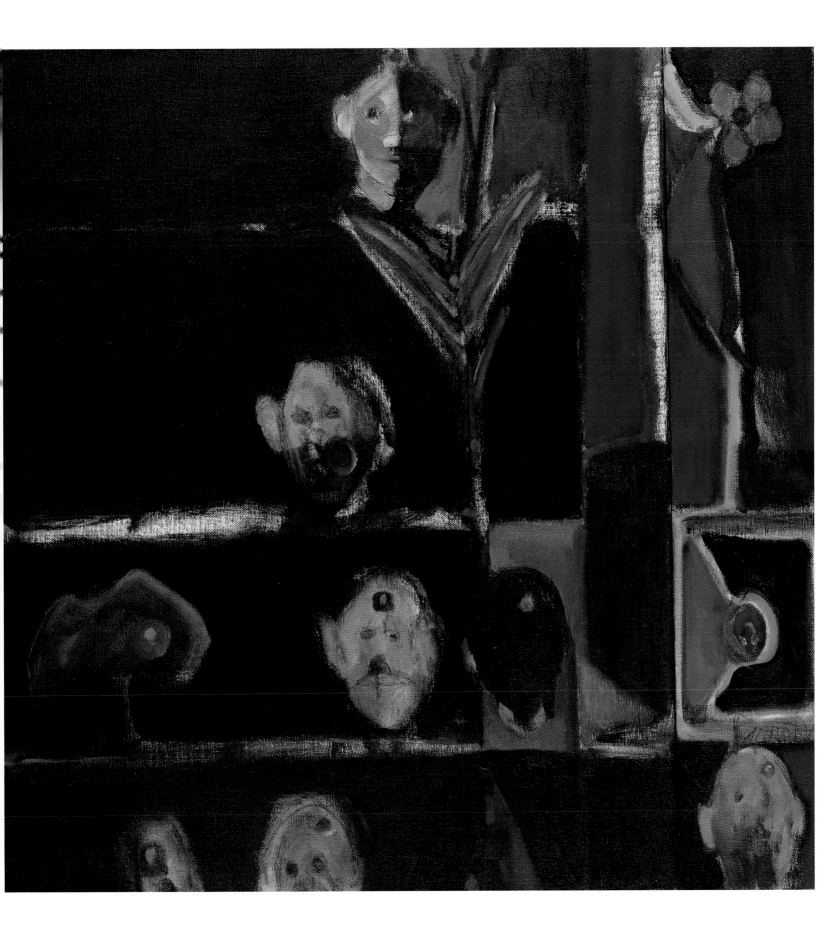

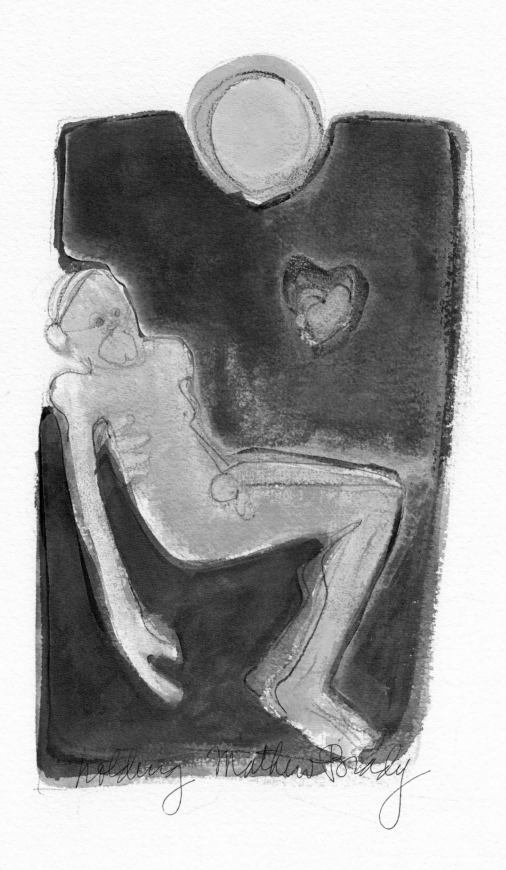

Holding Mathew Brady

Enigmas

A photographer with imperfect vision, a historian who would not or could not gaze on the unburied dead of his greatest subject: Mathew Brady, American enigma. John Ransom Phillips places Brady's failures of vision and of self-knowledge at the heart of his version of this American "original," part fool, part genius, part huckster, and part artist. The deficiencies, the crippling paradoxes, are attributable to the forces from which Phillips proposes to ransom this American Everyman. Free of his past—as Phillips portrays him—the enlightened Brady can now see himself in a clear light, as in a monologue delivered through a particular watercolor: "I allowed myself to become a victim of my own history" (right). Phillips depicts Brady as an impresario presenting a gallery wall of his portraits, all the heads blurry copies of his own cartoon bubblehead, versions of himself. What does Brady mean by "victim of my own history"? The particulars of "my history" are less relevant than his apparent sense of having no choice but to repeat himself, like one of the damned in Dante's *Inferno*. In another self-portrait he moans, "I never visited hell," yet pushing beyond its frame this very portrait shows a face wracked with anguish (p. 21). Does he say he never "visited" Hell because he now realizes he has always lived it?

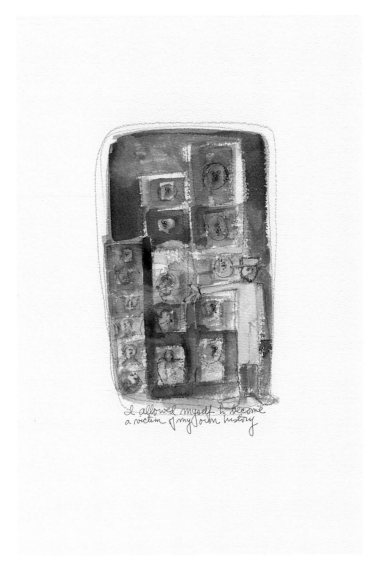

*I allowed myself to become
a victim of my own history*

[opposite]
holding Mathew Brady

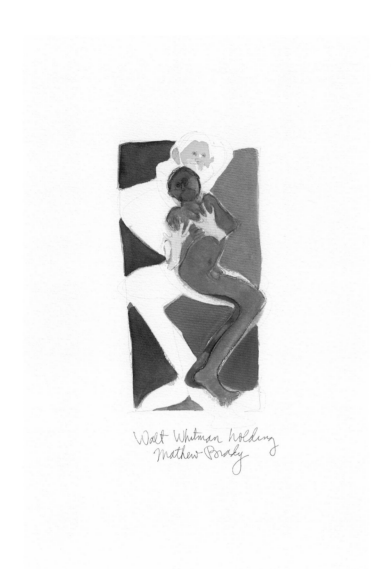

Walt Whitman holding
Mathew Brady

Mathew Brady's gift
to me was the surrender
of his shame. ~~He~~ *We felt*
the loss of ~~his~~ *our own innocence*

To ransom Brady means to free him from the chains of illusion, which includes freeing us from illusions about him. For we are part of the enterprise; like "you," "we" are present in the ensemble, subject also to "ransoming," to a certain transformation as we undergo the experience of releasing Mathew Brady from the clutch of his lesser self. A prophetic note, a Melvillean cry of warning, weaves itself among the paintings and texts that constitute the ransom proffered for the soul of Mathew Brady. We too are implicated in the process.

Far from moralistic in the narrow sense of listing virtues and vices in opposing columns, Phillips's work is deeply and personally moral. It echoes the Egyptian *Book of Going Forth by Day* (better known as the *Book of the Dead*), for which Phillips has produced dozens of watercolors on papyrus inscribed with sayings, incantations, and spells. The aim of ancient Egyptian funerary art was to tutor the newly deceased in how to undergo the passage from life to death, and according to ancient belief, back again. The texts and images of *Ransoming Mathew Brady* share the aim of the *Book of the Dead* to enlarge awareness of what it means to be alive by joining life to death, and by teaching that one must learn to die into new life. Both books teach how to breathe, how to love, and how to die again and again.

Me and mine,
loose windrows,
little corpses,
Froth, snowey white
and bubbles,
See, the prismatic
colors glistening and rolling

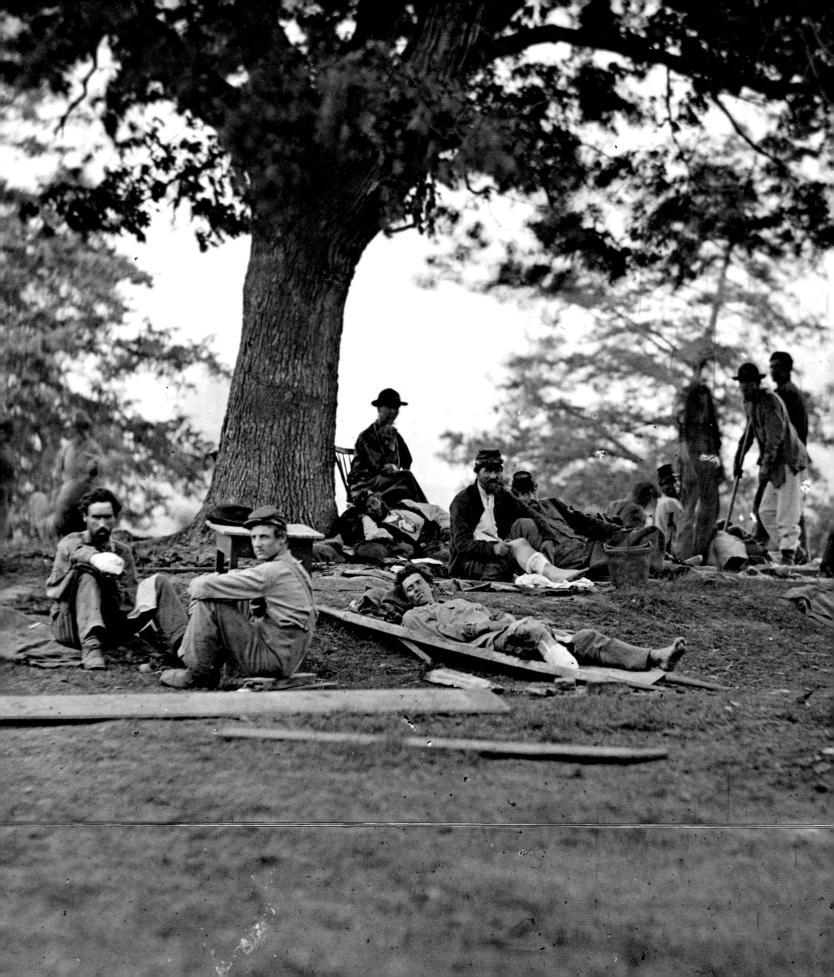

Mathew Brady — becoming — Walt Whitman

"Has any one supposed it is lucky to be born?" writes Whitman. "I hasten to inform him or her it is just as lucky to die, and I know it."[9] Whitman plays a major role in *Ransoming* as a fount of precisely this wisdom, that living and dying are continuous with each other, conditions of nature and of spirit at once. "If you want me again look for me under your boot-soles," Whitman writes in the closing lines of "Song of Myself":

> Failing to fetch me at first keep encouraged,
> Missing me one place search another,
> I stop somewhere waiting for you.[10]

His endings promise new beginnings. Whitman emerges as the clueless Brady's guardian figure, holding him in his arms, a slightly comic but nonetheless moving pietà. Whitman saves Brady by gathering him in his capacious arms.

the conflict hand to hand
the many conflicts in the
dark, those shadowy-tangled,
flashing moonbeam'd woods—
the writhing groups and squads . . .
the indescribable mix . . . the
devils fully rous'd in human
hearts

I joyously
sing the dead
the interior history of the war
will never be written,
perhaps must not
and should not

Mathew Brady—becoming—Walt Whitman

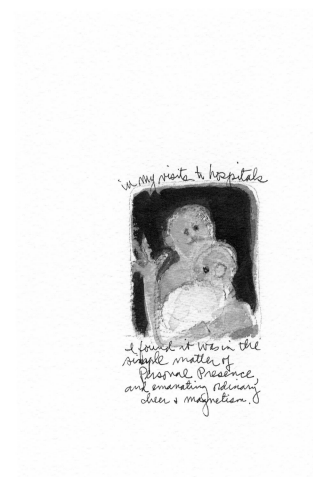

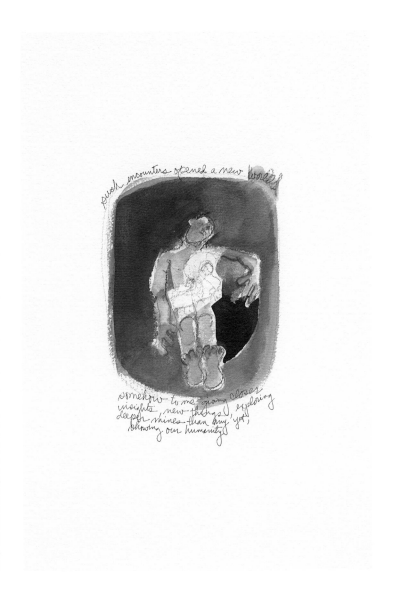

in my visits to hospitals
I found it was in the
simple matter of
Personal Presence,
and emanating ordinary
cheer and magnetism.

such encounters opened a new world
somehow to me, giving closer
insights, new things, exploring
deeper mines than any yet,
showing our humanity

Did anything like this happen in "real" life? No matter. This Whitman belongs to Phillips's conception. There is enough to go on in actual history to warrant our imagining a link between the two men. In articles for the Brooklyn press in the late 1840s about his meanderings in lower Broadway, Whitman singled out Brady's daguerreotype gallery for praise. More than once Whitman sat at the Brady studio for his own portrait. Late in life he recalled conversations with Brady about the historical value of portrait photographs.

The relation that Phillips perceives as most critical to the ransoming of Brady, however, concerns how each experienced the Civil War. Brady sent cameras to the front, occasionally visited there, and had himself photographed gazing over empty fields. As far as we know, he never looked directly at battlefield corpses, the shocking human remains of the most memorable Civil War photographs. The contrast with Whitman's wartime experience—nursing the sick, tending the wounded, easing the dying—could not be more dramatic or revealing. Whitman's role is definitive. His bewitching riddles such as "the unseen is proved by the seen" and "I and this mystery here we stand,"[11] his belief that body and soul (in the words of the *Book of the Dead*) are "competing for my being," offer alternatives to Brady's conspicuous aversion to the body, to death and decay, to pain and sorrow. Whitman's role in Phillips's work contributes to the sense that saving a soul such as Brady's through "ransoming" is both transformative and celebratory.

To ransom is to rescue, to liberate Mathew Brady from misperceptions about his role in the drama of America. But "ransom" also evokes the artist: to ransom Brady is also to remake him as Ransom, a new identity. Morphed into his own Ransom, so to speak, Brady saves himself in both senses of the double entendre. The essential point is that "ransoming Mathew Brady" entails a real

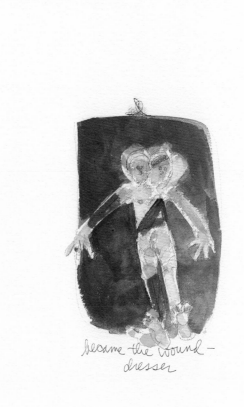

became the wound—dresser

I became the wound-dresser

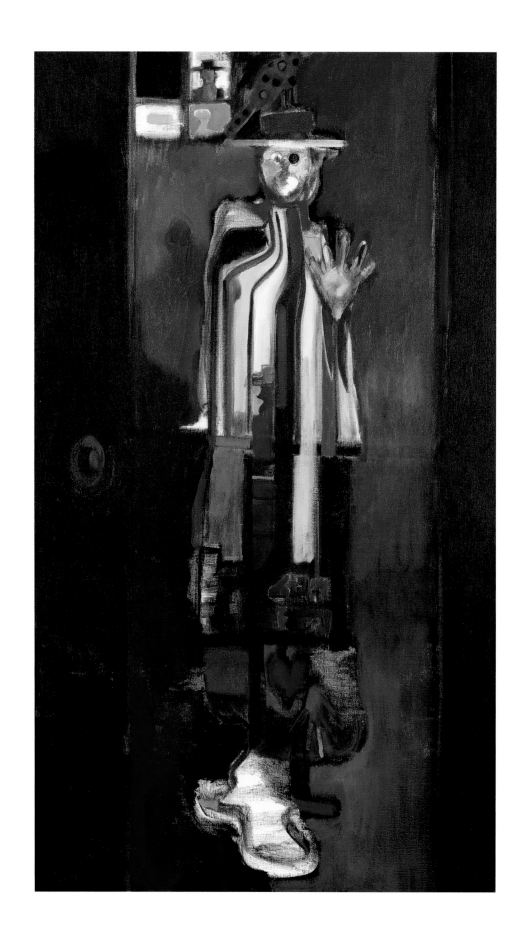

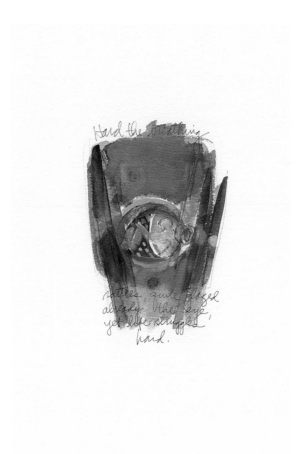

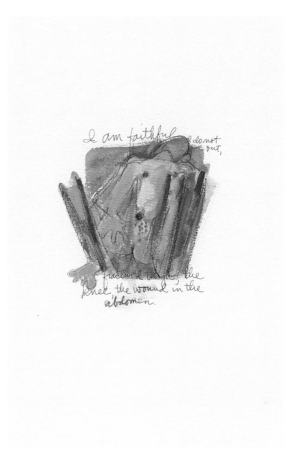

exchange, not another masquerade of a staged identity as in the portrait studio. The ransomed Brady, according to the rules of the work, gets incorporated into John Ransom Phillips, incorporated as inner eye and voice of the artist, the compounded powers that enable the work in the first place: Ransom bespeaking Brady, Brady achieving himself in the mirror of Ransom's eyes. What is imagined is seamless exchange—"what I assume you shall assume"—that becomes the ground for going forth.[12]

What quickens the desire to rescue is the enigma of this paradoxical figure, the man within the trademark, Brady of Broadway. He is the half-blind left-eyed photographer whose lens projects the lineaments of his own face in another mirroring act, like "you" taking on the guise of Brady. Brady-Ransom transforms Brady's work from a series of pictures telling tales into a phantasmagoria of masked faces and shifting roles, a carnivalesque of recurrent episodes bathed in seductive colors and forms. The show reveals Brady becoming Ransom and vice versa, which is what "ransoming" is all about.

Hard the breathing
rattles, quite glazed
already the eye,
yet life struggles
hard.

I am faithful
I do not
give out,
the fractur'd thigh, the
knee, the wound in the
abdomen.

[opposite]
Brady Through a Glass Door, 2006
oil on canvas, 70 × 40 inches

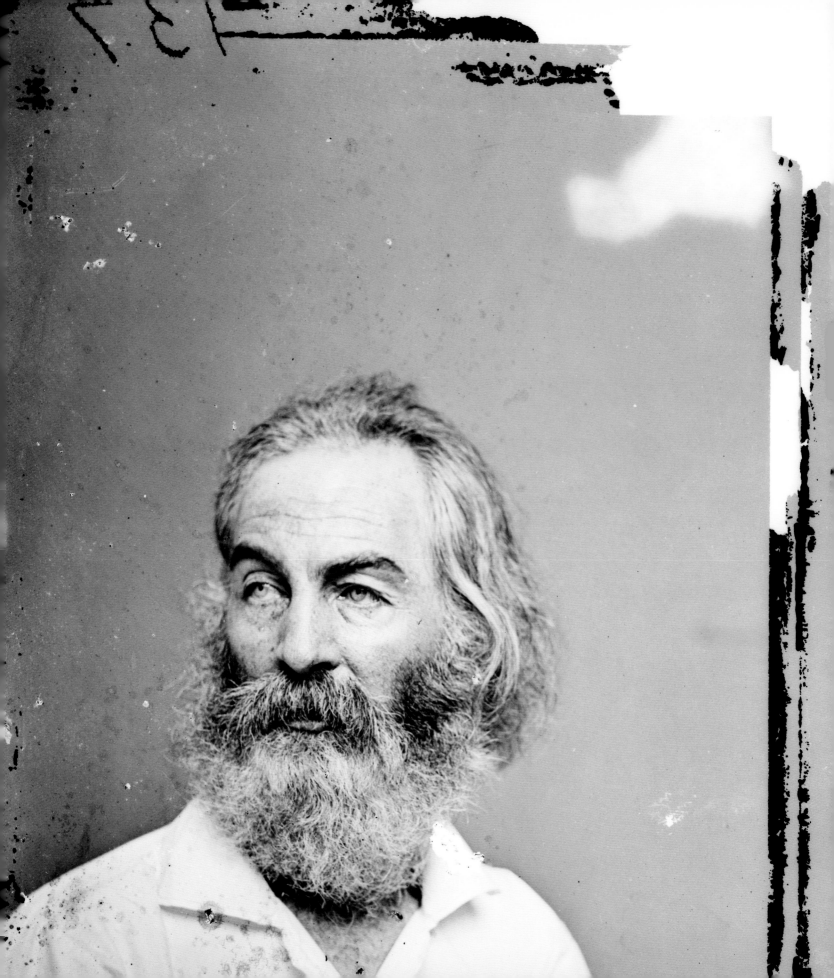

it is I you hold
and who holds you,
I spring from the
pages into your arms—

I replace emulation
with ecstatic and erotic
encounter—an act of
transgression and affirmation

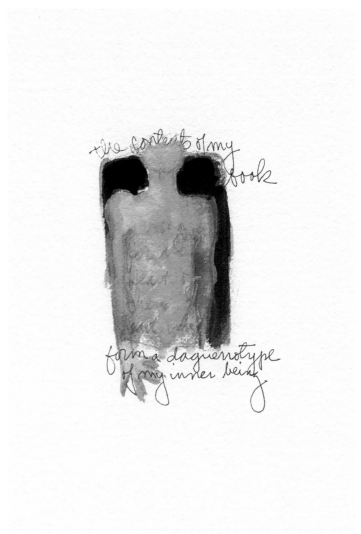

my portrait becomes part
of my poem:
its opening lines, its
motto.

the contents of my book
form a daguerrotype
of my inner being

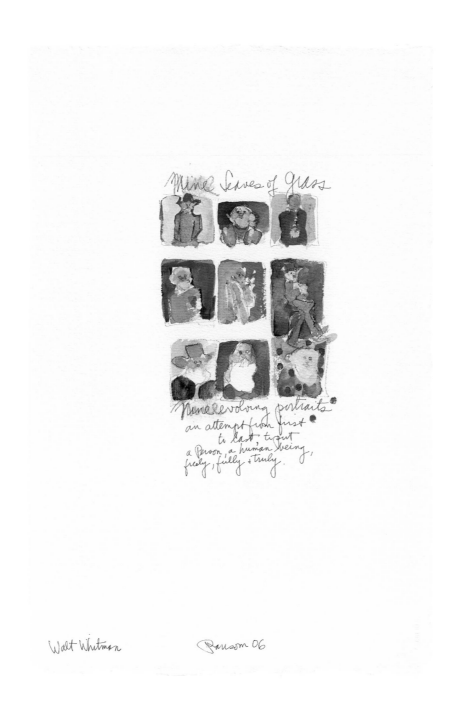

Walt Whitman Ransom 06

Nine Leaves of Grass
Nine evolving portraits
an attempt from first
to last, to put
a Person, a human being,
freely, fully and truly.

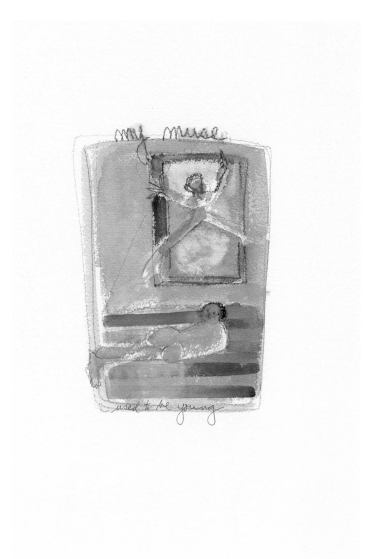

departing muse

my muse
used to be young

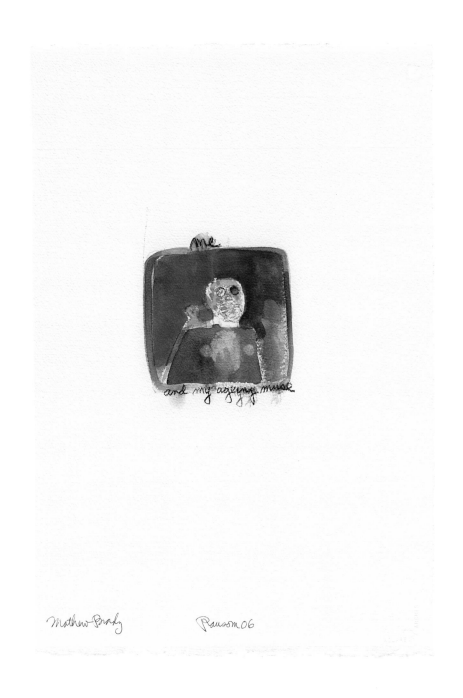

Mathew Brady Ransom 06

me
and my ageing muse

Details of My Life Remembered, 2005
oil on canvas, 50 × 50 inches

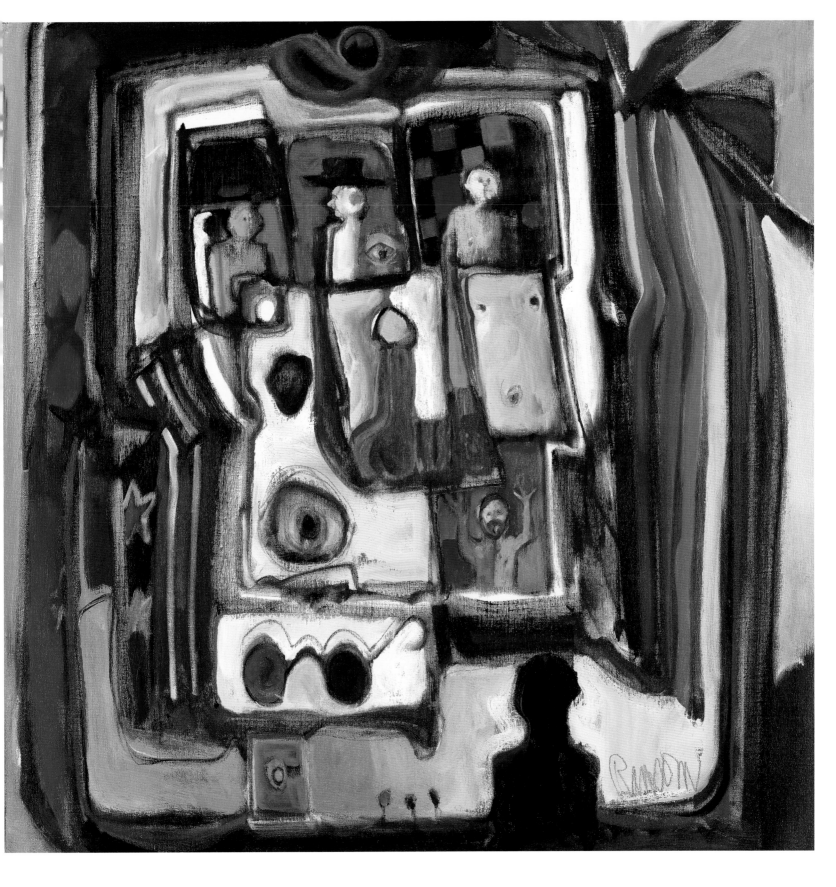

Heaven: Mathew Brady Embraces the Underworld, 2005
oil on canvas, 62 × 46 inches

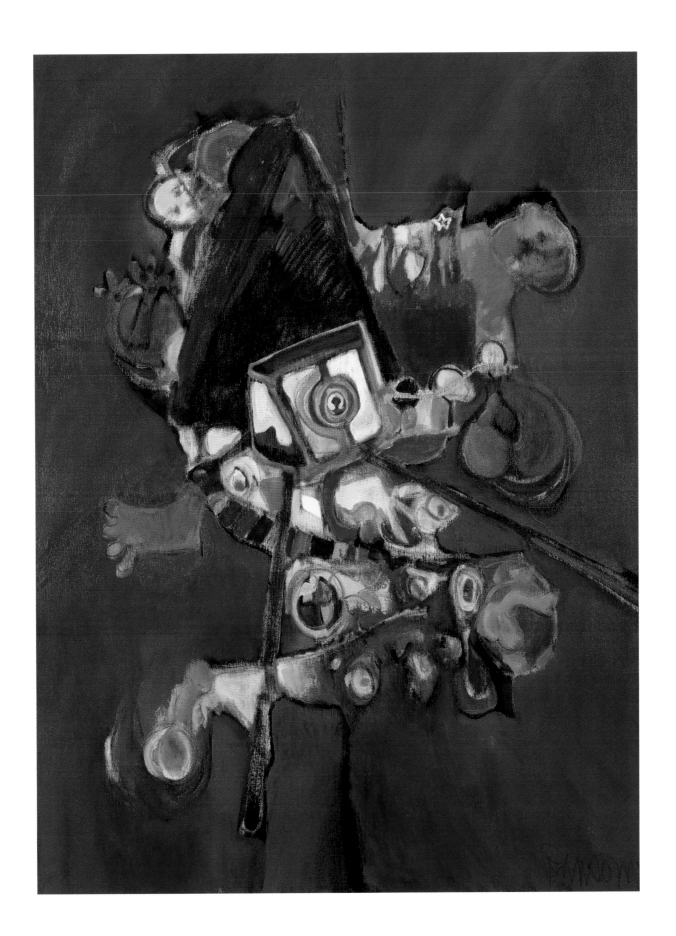

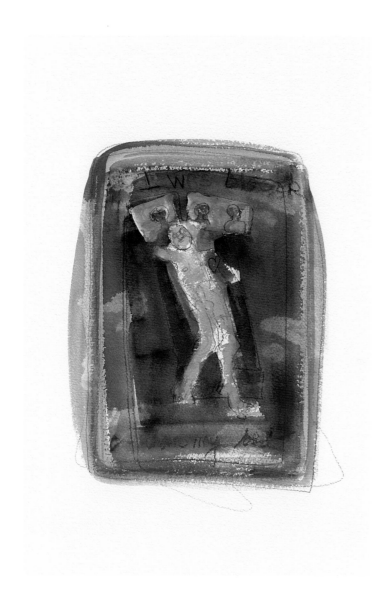

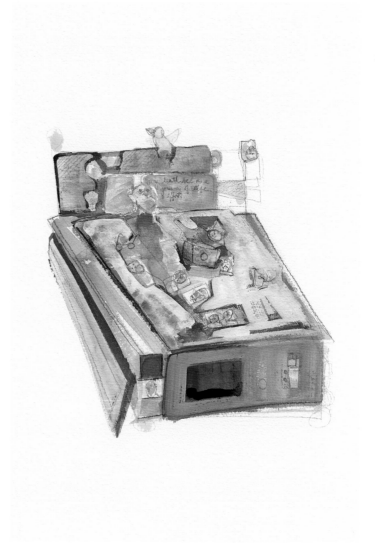

*I was bigger
than my bed*

*my death bed as a
journey of life
and effort.*

[opposite]
Sleeping With Mathew Brady, 2006
oil on canvas, 60 × 50 inches

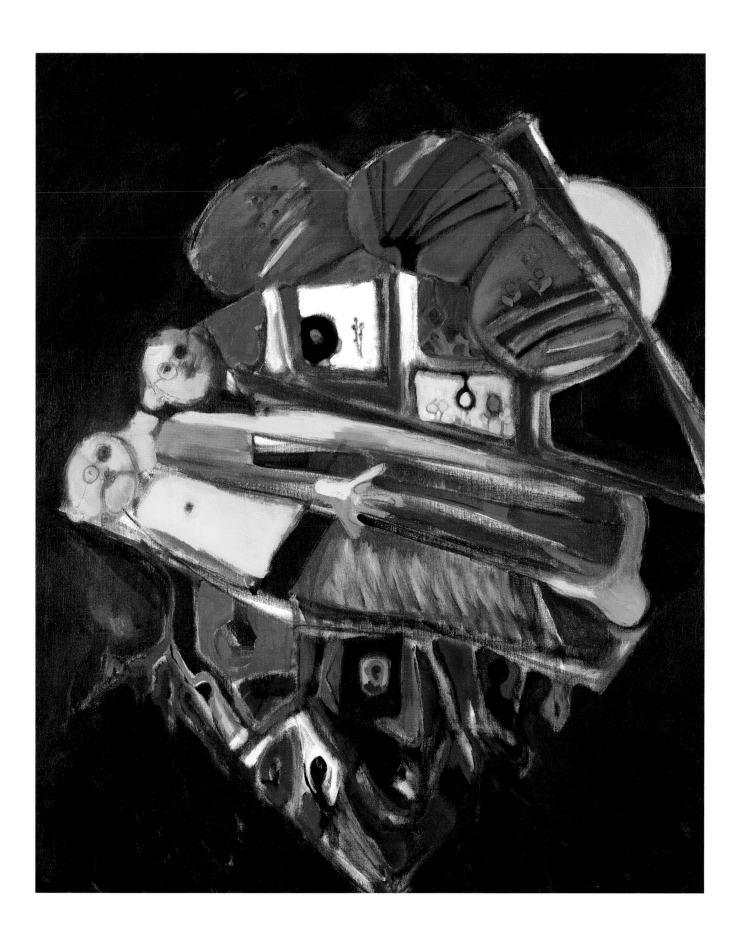

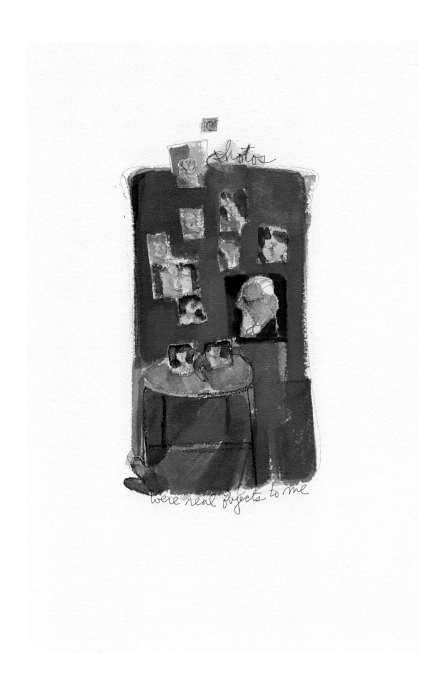

photos
were real objects to me

untitled

untitled

[opposite]
Last Days, 2005
oil on canvas, 60 × 50 inches

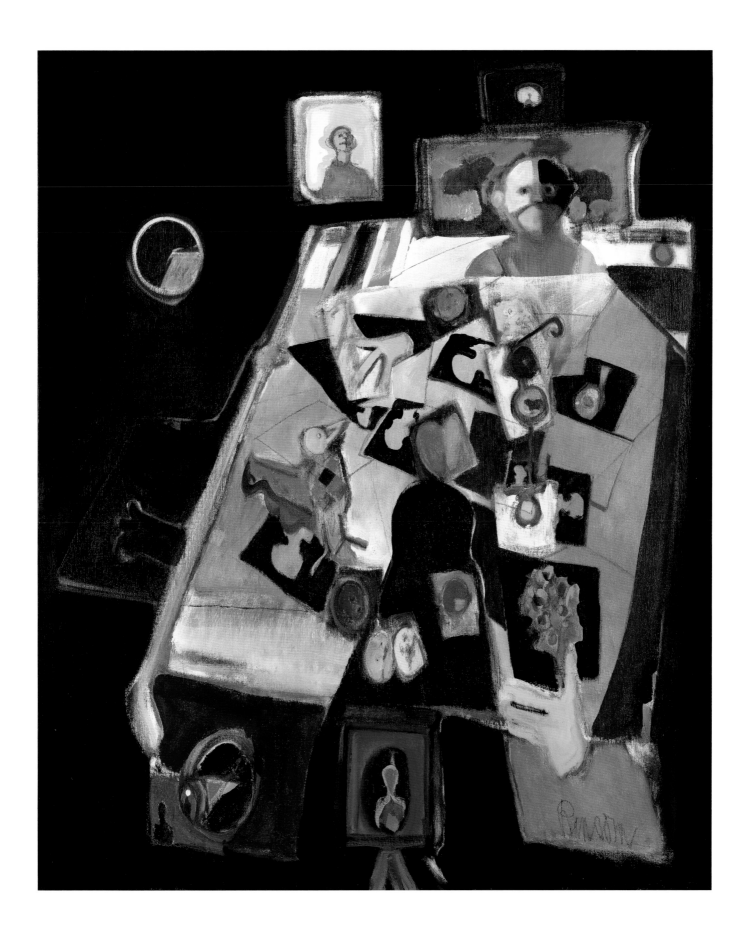

my life
was like a quilt

at times
I felt illuminated

photography
took over
my whole life

Mathew Brady Ransom 06

my whole life
was made up of
repetition

*I did to my son Andrew
what was done to me*

*there was nothing that was
autobiographical in my
work because I
could not re-visit my
childhood.*

there was no sign of the female
in my work

my mother
sucked all the
energy out of me
so that I identified
love with this theft.

Mathew Brady Ransom 06

as a baby
I was visited

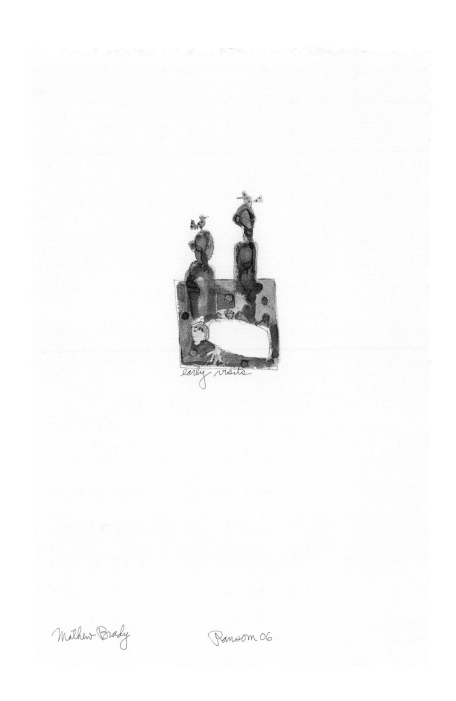

early visits

Mathew Brady Ransom 06

early visits

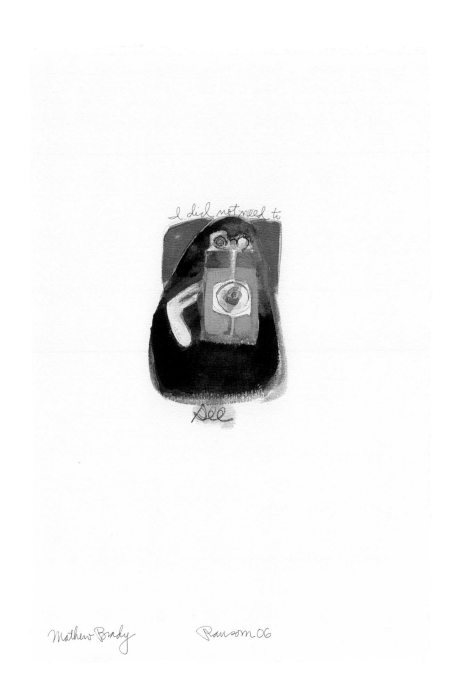

Mathew Brady Ransom 06

I did not need to
see

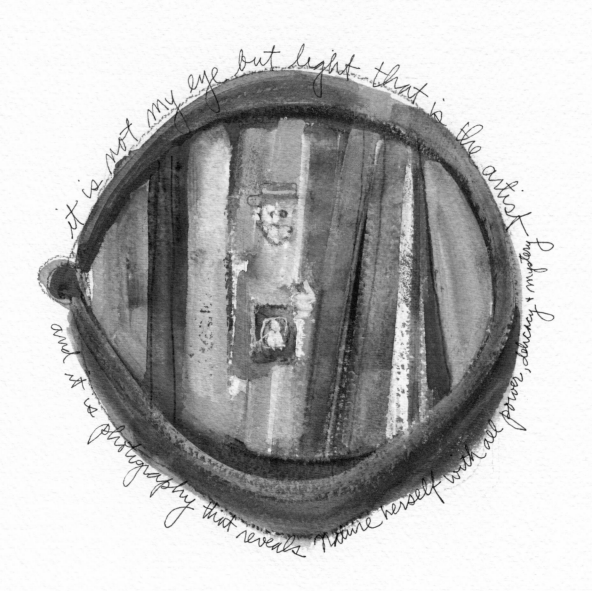

it is not my eye but light that is the artist

and it is photography that reveals Nature herself with all power, delicacy & mystery

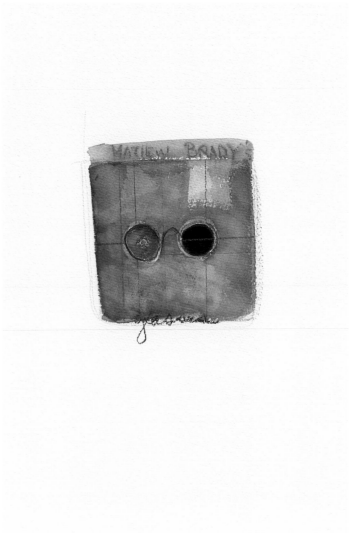

getting weaker

MATHEW BRADY'S
glasses

[opposite]
it is not my eye but light that is the artist
and it is photography that reveals Nature herself with all power, delicacy and mystery

Inventory of My Eyes, 2006
oil on canvas, 40 × 50 inches

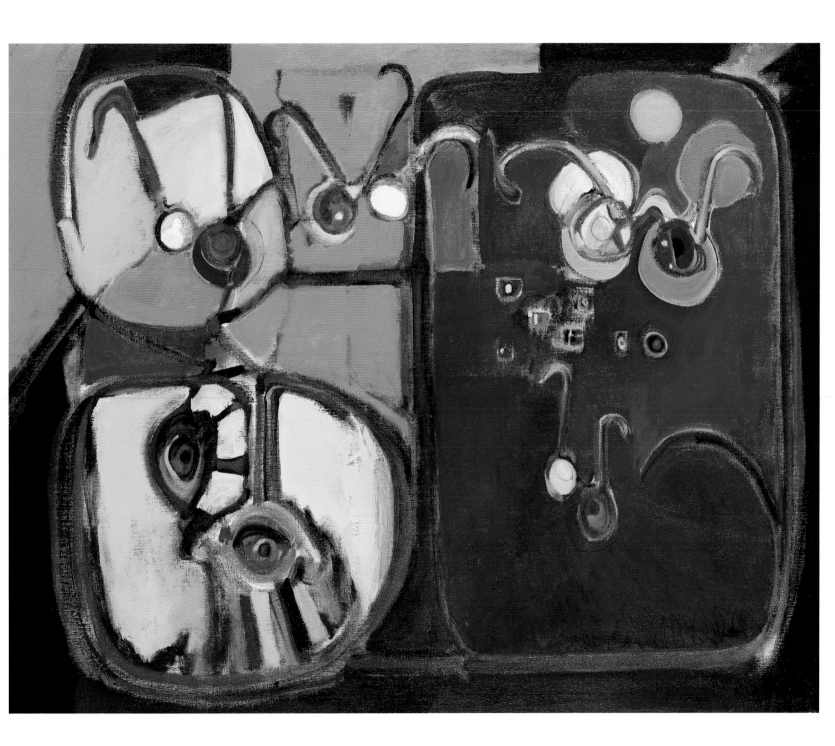

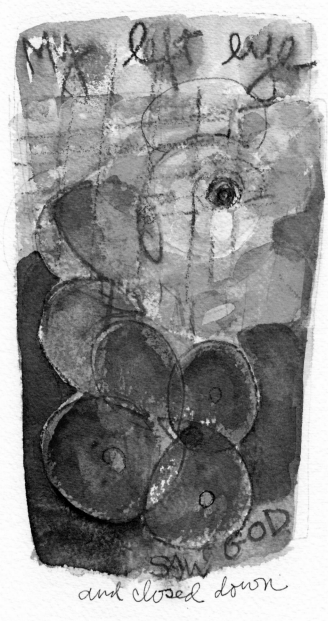

and closed down

Mathew Brady Ransom 06

my left eye
fell

[opposite]
my left eye
SAW GOD
and closed down

left eye seeing

Mathew Brady *Ransom 06*

left-eye seeing

[opposite]
left eye seeing

left eye seeing

I lost my vision
early

[opposite]
left eye seeing

DIMINISHING EYESIGHT

GROWING BLIND

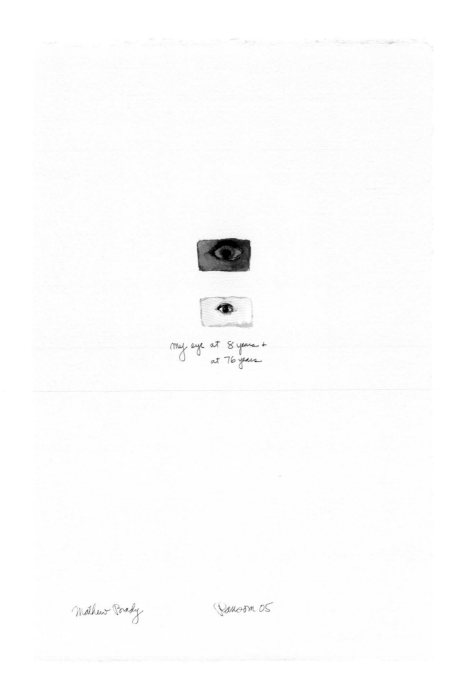

my eye at 8 years and
at 76 years

Mathew Brady: As He Would Like to Be Remembered, 2006
oil on canvas, 50 × 40 inches

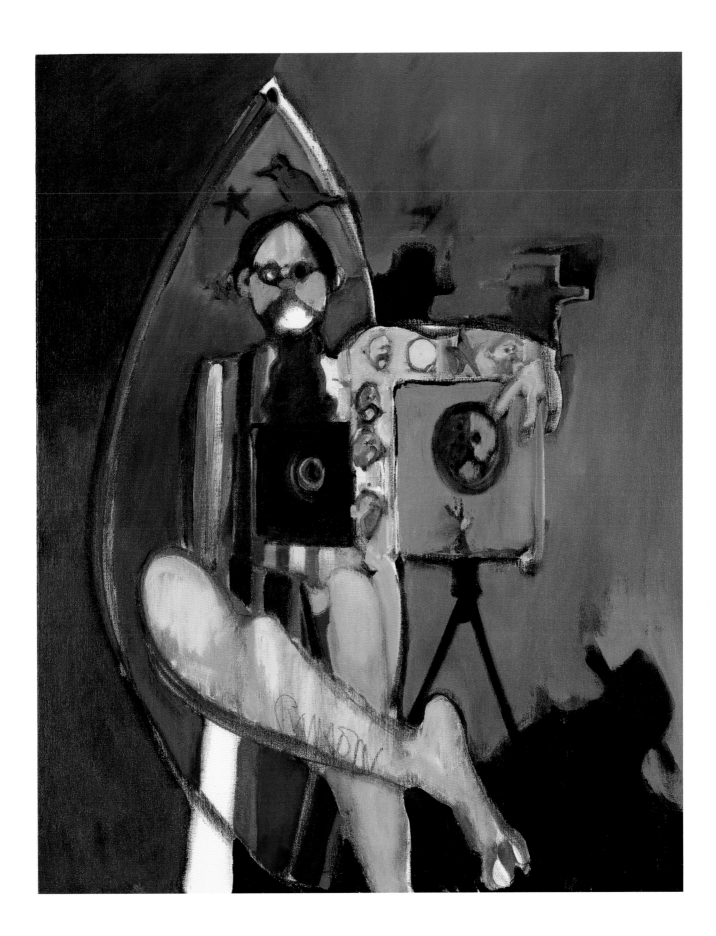

BRADY
my name signifies both a place and process
TRANSFORMATION

the VISIONARY artist
as the center of a factory

"My perception was blue"

→ •• ←

Phillips interprets the historical Mathew Brady; he does not make him up out of whole cloth but adheres to the known facts, which are relatively scarce considering Brady's fame. *Ransoming* attests to the historical figure, makes him even more vivid, more accessible, a living character in an elaborate visual fiction who refers back to a figure in past life. *Ransoming* adds to the record, a work to be recommended to historians and students seeking knowledge of Brady, photography in antebellum America, or the trauma of civil war. We know that Brady tightly guarded his private life. (Indeed did he have a private life? What were his dreams, secret desires, buried fears?) Phillips deploys paint and language to deduce an inner life from known facts, to elicit a more complex Mathew Brady than we have known, the skilled entrepreneur who wheedled and beguiled his way to fame on the eve of the Civil War as "prince" and "father" of American photography.

In Brady's commercial success we can trace opportunities unique to the age. Brady created in his gallery a prime artifact and institution of the age, a place of illusion-making in service of an idea of America. His gallery created images of "Illustrious Americans," self-made individuals who transcended self for the sake of the Republic, a place where America and celebrity came to seem synonymous. The public came to depend upon the gallery as a source for pictures of what society most valued: self-contained individuals comfortable in their own almost invariably white skins, yet firm in their belief in the larger cause of the Republic

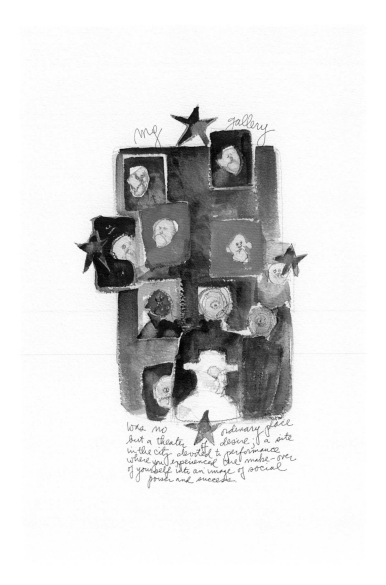

*my gallery
was no ordinary place
but a theater of desire; a site
in the city devoted to performance
where you experienced the make-over
of yourself into an image of social
power and success.*

73

I was the most photographed photographer

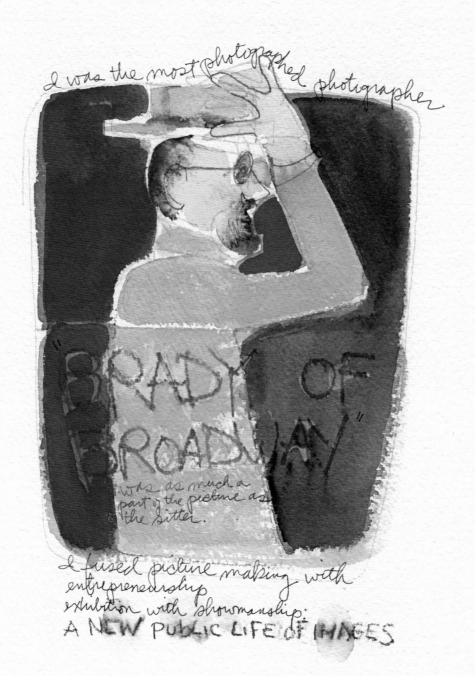

"BRADY OF BROADWAY"

was as much a part of the picture as the sitter.

I fused picture making with entrepreneurship, exhibition with showmanship: A NEW PUBLIC LIFE OF IMAGES

and an emerging "American way of life." And the gallery in turn represented Mathew Brady, his success, his growing fame. It put him on display in self-portraits that also revealed his fallible eyesight, his blue-tinted spectacles, the blue glass of the skylight. Phillips shows the gallery as the site of tensions between light and dark, color and void, life and death. Brady's place in the world both hid and exposed the turmoil in his own heart.

Brady of Broadway: who was he? "BRADY," reads one watercolor, "my name signifies both a place and process, TRANSFORMATION" (p. 72). In the watercolors Phillips gives Brady the voice of self-knowledge, the acquired voice of Brady ransomed. What did it take for a young man from the provinces in upstate New York to make his way to the top in antebellum America? Except for the slave-holding South the country underwent in those years the phenomenally rapid and revolutionizing transformation into the commercial market society that remains the national ethos. The opening of the Erie Canal in 1825 made New York the nation's major metropolis and epitome of the pursuit of private wealth.[13]

But the national ethos was not yet homogeneous. Divided north and south between freedom and slavery, the country was further torn by race; whites and blacks faced radically antagonistic prospects and experiences. Racial hostility if not slavery itself made it hard to credit the rhetoric that portrayed a united country committed everywhere to life, liberty, and the pursuit of happiness for all. Yet the delusion had the force of credo, with Brady of Broadway one of its most ardent proponents. The bombardment of Fort

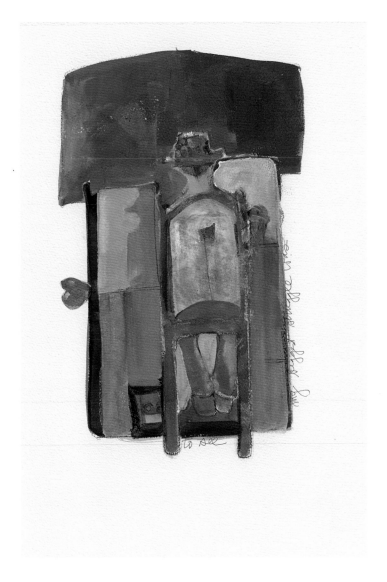

*my biggest struggle was
to see*

*[opposite]
I was the most photographed photographer
"BRADY OF
BROADWAY"
was as much a
part of the picture as
the sitter.
I fused picture making with
entrepreneurship
exhibition with showmanship:
A NEW PUBLIC LIFE OF IMAGES*

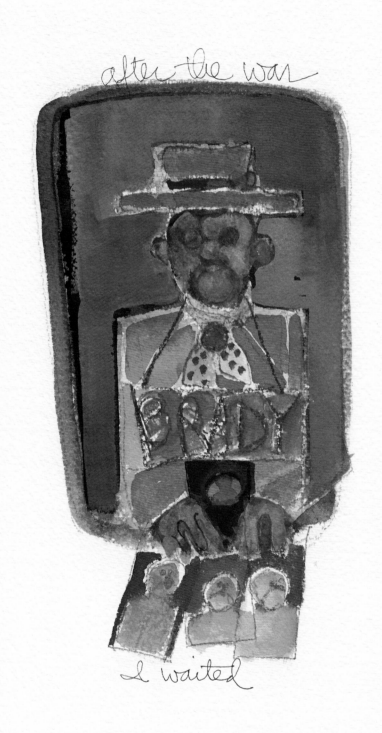

Sumter in 1861 awoke the nation—the two nations, white and black—to the dread reality of a country riven by ferocious antagonisms.

Like the waters of the Erie Canal, Brady started life near Lake George (he was born in 1823 or 1824), then flowed in a rush down to the big city in 1839, the same year Daguerre in France and Talbot in England announced their respective inventions of photography. He worked briefly in a department store, then for a small manufacturer of jewelry cases, and in 1844 took up photography and opened a portrait studio at the corner of Broadway and Fulton Streets, the heart of commercial New York. How did he rise so rapidly that by 1851, not yet 30 years old, he was described as the "fountainhead" of portrait photography? And how did he approach the delusion of a united country?

The two questions dovetail. He rose to fame as a celebrant of "Illustrious Americans," of the delusion of unity. When civil war erupted, he rushed at once into the fray. This would be his greatest triumph, his organization of a corps of photographers to follow the armies and make an unprecedented firsthand record in photographs of the war and its aftermath. But firsthand did not mean that he himself witnessed everything. "I hired others to climb the tree," Phillips has him confess in one watercolor (right); it is the tree of life on which "others" risked life and limb as his surrogate eye.

Brady's collection consisted of pictures he commissioned, bought, collected, published, and otherwise acquired and claimed as personal property. He never recovered his investment, nor did he ever realize his wish to see his photographs installed as an official national memorial to the bloodshed that saved the Union.

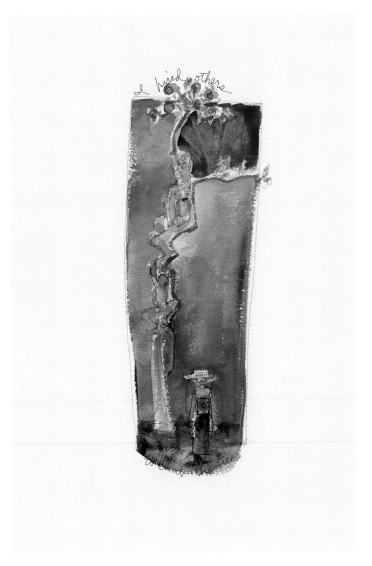

*I hired others
to climb the tree*

[opposite]
*after the war
I waited*

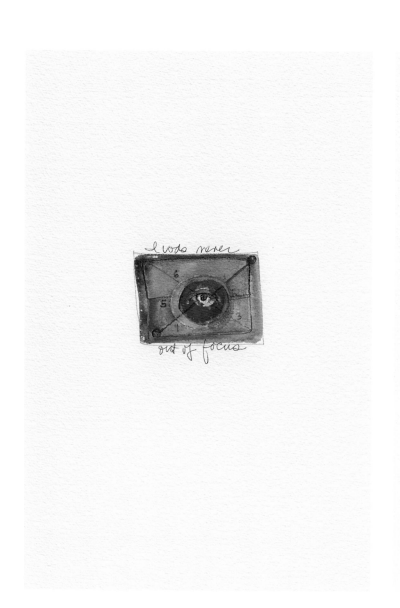

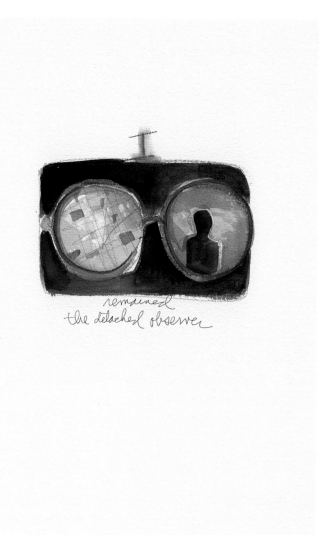

I was never
out of focus

I
remained
the detached observer

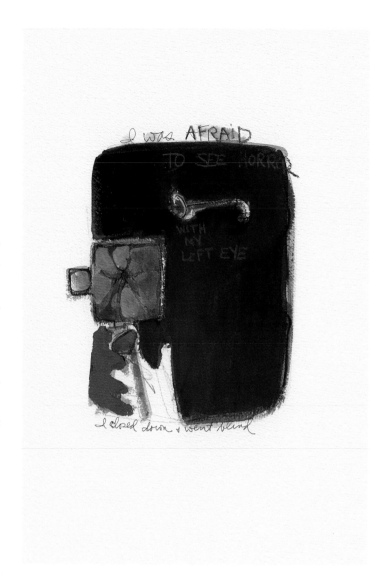

After the war his personal fortunes spiraled downward, and by 1896 when he died in near destitution, he was a forgotten old man. The muted tones of *after the war I waited* (p. 76) capture the pathos of the demise of the once-celebrated Brady of Broadway.

If you look closely, as Phillips does, even during his years of success Brady showed signs of inward suffering. The bad left eye may have resulted from a childhood inflammation; still, the bad eye can be taken as a symptom and ailment of something deeper, a deficiency of visionary seeing. The blue light, the tinted spectacles: these mark the labyrinth of the Brady enigma. "I remained the detached observer," Phillips has him observe, and the watercolor shows tinted spectacles that dim more than block the harsh light (opposite page). "My studio was bathed in blue light which reinforced my blue tinted glasses; the sitter, so tinted, came to be appropriately identified with me" (p. 82).

Sitters yearned to be so identified, to surrender themselves, their physical being, their likenesses, to become other to themselves in the Brady blue light, the glow that effaced the particular on behalf of the general, the idea of "Illustrious Americans." In promoting the concept of "celebrity," the Brady studio presaged Andy Warhol's factory, in which difficult truths gave way to easy replications and evasions. "I never visited hell," Phillips's ransomed Brady confesses (p. 21); "I was afraid to see horror with my left eye; I closed down and went blind" (right). Warhol: "My idea of a good picture is one that's in focus and of a famous person."[14] Brady: "I was never out of focus" (opposite page, left). *Gallery (Searching for Celebrity)* (p. 87) shows a wall of images as if on a proscenium stage, with Brady

I was AFRAID
TO SEE HORROR
WITH
MY
LEFT EYE
I closed down and went blind

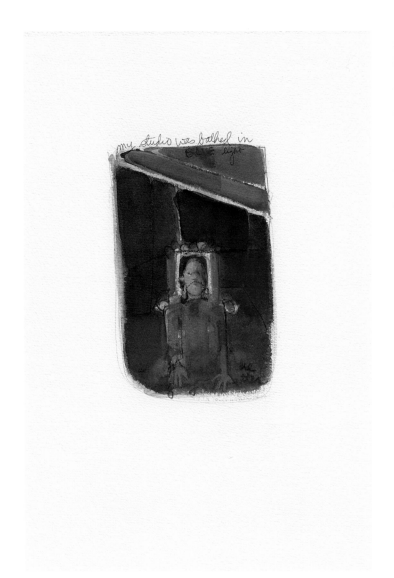

my studio was bathed in
BLUE light

my perception was blue

seen from the rear looking up. We see Roman busts and a skull, and at the top, icons of the tree of life and the bird of resurrection that displace "celebrity" with ancient celebrations of life.

Who was Mathew Brady? We have an image of a small dapper man with appurtenances: wooden studio chair, a seated pose before an unseen camera, cut-away coat and trimmed goatee, Van Dyke on the chin flashing *artiste*. Always the camera, the apparatus unseen, the same image carried over into army camps and near battlefields. Brady standing with straw hat against the glare, leaning on a tree as if on a classical column in his studio; or sitting in front of a tent with knees tight on a small camp chair among generals and officers in uniform; or sideways or backward to the same unseen camera, as if peering, pouring his eyesight over the wooden fence that separates his side of here from the nether side of there. Blank distance, his hunched shape reflected in the shallow pool that lies between his narrow back and ourselves behind him, our eyes as if the camera.

We know him, his appearance at least, from photographs in which he staged himself as the very epitome of the figure that would naturally be photographed by none other than himself, Brady of Broadway, proprietor of rooms in lower Manhattan and in Washington, D.C., where the already-famous by wealth or power or family name arrived at his behest to sit for portraits that would, with the seal of his name, confirm and enhance that fame for public consumption. And not incidentally reflect its glow of prestige back onto him, democratic simulacrum of royal artists basking in the eminence of their clients. His self-fashioning fashioned a public role for the studio photographer in post-aristocratic society, to make "pose" available to anyone with the price of admission.

still life

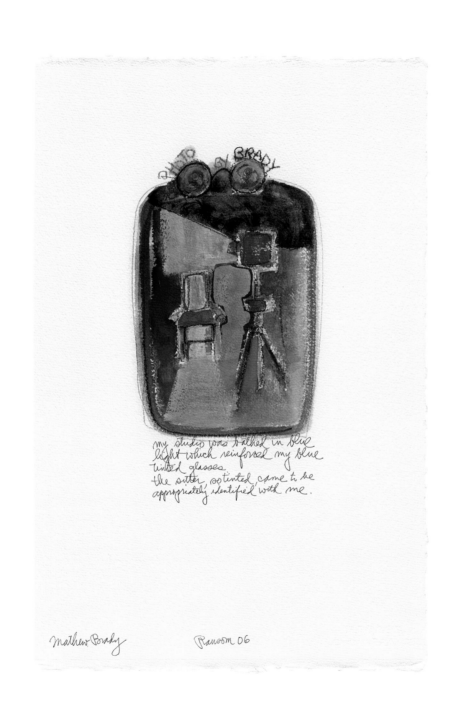

my studio was bathed in blue
light which reinforced my blue
tinted glasses
the sitter, so tinted, came to be
appropriately identified with me.

Mathew Brady Ransom 06

PHOTO BY BRADY
my studio was bathed in blue
light which reinforced my blue
tinted glasses
the sitter, so tinted, came to be
appropriately identified with me.

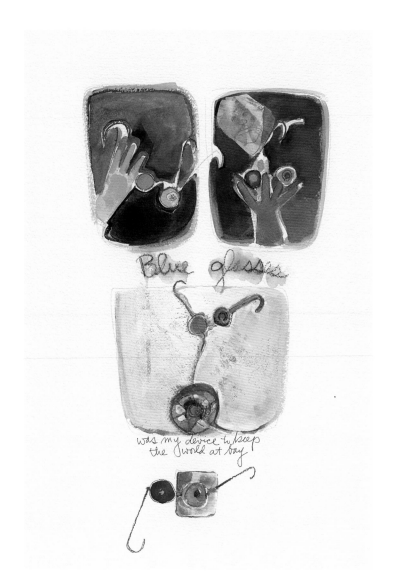

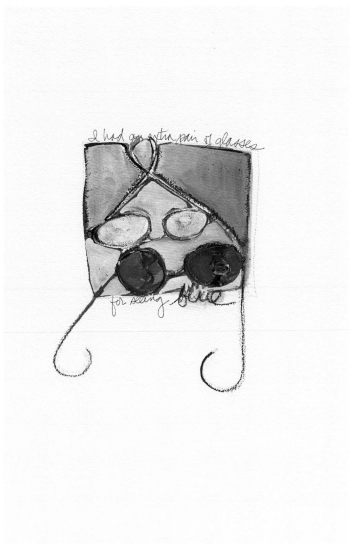

Blue glasses
was my device to keep
the world at bay

I had an extra pair of glasses
for seeing blue

Mathew Brady Ransom 06

entering
my perception

my perception

Mathew Brady Ransom 06

ENTERING
my perception

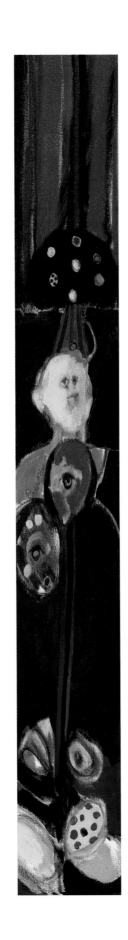

Eyesight, 2006
oil on canvas, 70 × 10 inches

[opposite]
Gallery (Searching for Celebrity), 2005
oil on canvas, 62 × 46 inches

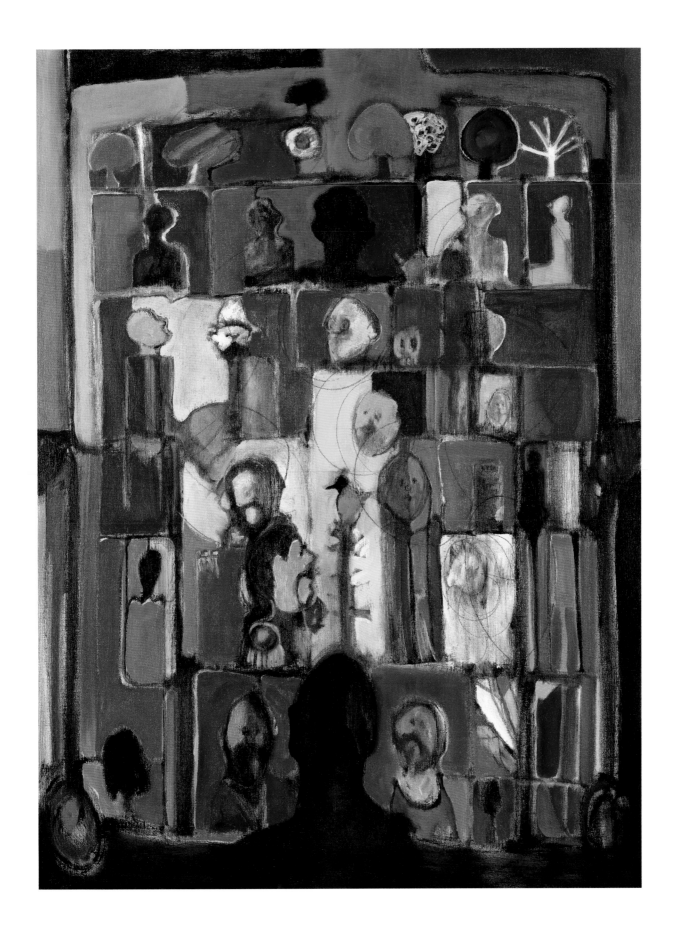

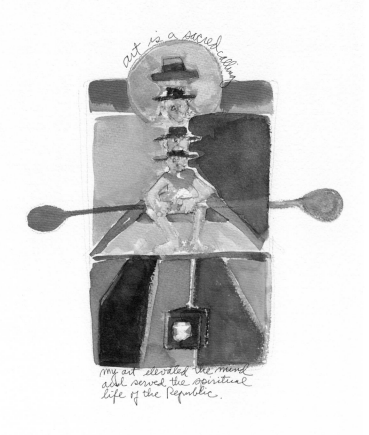

art is a sacred calling

my art elevated the mind and served the spiritual life of the Republic.

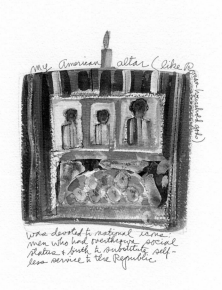

I imbibed a new kind of portraiture to be made with an air of generalization + historical allusion so as to diminish the force of mere likeness

my American altar (like Roman household gods)

was devoted to national icons: men who had overthrown social status + birth to substitute self-less service to the Republic

art is a sacred calling
my art elevated the mind
and served the spiritual
life of the Republic.

I imbibed a new kind of portraiture
to be made with an air of generalization
and historical allusion so as to
diminish the force of mere likeness

my American altar (like Roman household gods)
was devoted to national icons:
men who had overthrown social
status and birth to substitute self-
less service to the Republic

"A new kind of portraiture"

━━━━▶ •• ◀━━━━

In a rare newspaper interview in 1891 the elderly Brady recalled the noble calling of his youth: "From the first, I regarded myself as under obligation to my country to preserve the faces of its historic men and mothers."[15] This concept of filial obligation may also have been Brady's primal delusion. "I imbibed a new kind of portraiture," Phillips has Brady disclose in a watercolor monologue, "to be made with an air of generalization and historical allusion so as to diminish the force of mere likeness" (opposite page, top right). The sneered term "mere likeness" expresses the historical Brady's disdain toward the "merely photographic" of the high-art tradition: "art is a sacred calling," he pronounces in a watercolor in full delusional register; "my art elevated the mind and served the spiritual life of the Republic" (opposite page, left).

"Mere likeness" offends Brady. It implies the body as Whitman regarded it, "undisguised and naked," rather than the *idea* of the body, the abstract body of the nation. But in fact "mere likeness" is not only what the camera does best, what it cannot help but doing—to transcribe what the lens sees. Mere likeness is also what Brady does best (though he does not recognize or acknowledge it) when he sees with his impaired left eye. In Phillips's Brady, it is the left eye that sees the sacred, that apprehends God in all things. In the oil painting *Left-Eyed Vision* (p. 93), the oval contained within the perimeter of the eye suggests that the sacred flows directly from the vagina. Walt Whitman's reference to "egg" in the following passage joins his own preference for "mere likeness" with the maternal source of things: "I believe a leaf of grass is no less than the journey-work of the stars, And the pismire is equally perfect, and a grain of sand, and the egg of the wren."[16] "I do not press my fingers across my mouth," Whitman writes; "I keep as delicate around the bowels as around the head and heart."[17] The blue light of Brady's studio effaces any trace of bowels and such, redrawing self-likeness into likeness to type, the way he typecast his Illustrious Americans by posing them in the formal style and manner of Roman household gods.

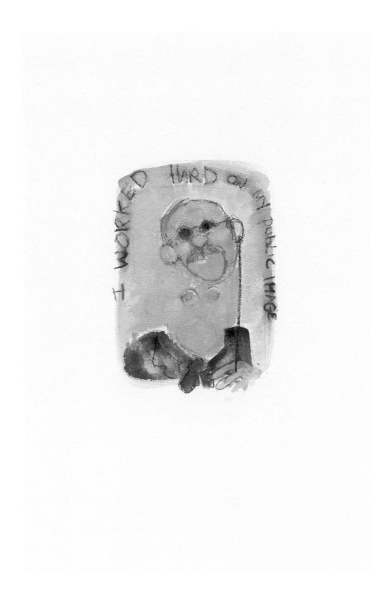

*I WORKED
HARD ON MY PUBLIC IMAGE*

Brady too cast himself as a type: self-made entrepreneur as selfless servant of the Republic. Brady the portraitist was already Brady the historian, maker and curator of a national gallery of worthy faces. It was in the tense 1850s, the decade of Brady's meteoric rise, that he marketed prints of Illustrious Americans as amulets against the menacing conflict over slavery. After Sumter in 1861, like other young Americans innocently eager for the glory and adventure of battle, he raced to Bull Run, not in military dress but in his artist's smock and duster. When he returned from the chaotic retreat he photographed himself as if the picture proved he had been there, survived the wild disarray of retreat, and at least intended to witness the battle. Brady of Broadway had transformed himself (while remaining the same) into Brady the seeker of likenesses of war, war's similitude if not the thing itself, which he assiduously avoided.

Mere likeness raised the threatening prospect that photography in itself might suffice—lens, film, chemistry, and physics of light—without the aura of art. Art presumed blue light and staged pose, the entire theatre of the studio. Phillips's Brady was not only master of the pose but himself the model. "I worked hard on my public image," Phillips has him admit in one watercolor that shows him with

blue eyeglasses, purple collar, and blue cravat (opposite page, left). He confesses, in regard to mere likeness, that "my biggest struggle was to see" (p. 75), but boasts (the words are Phillips's): "I was the most photographed photographer[,] 'BRADY OF BROADWAY' was as much a part of the picture as the sitter" (p. 74).

Showmanship is not just Phillips's unillusioned insight but the proud self-image of the historical Brady, who understood perfectly the role of craft, display, and exhibition in the emerging culture of hotel lobbies, new department stores, crowded streets, portrait galleries, and theatres. This was Brady's milieu, the world he mirrored and the mirror in which he saw himself. No wonder Phillips portrays Brady's gallery as a "gallery of dead." *Death Surrounds My Camera* (p. 92) shows dead faces like dead stars in a darkly glowing blue sky, some shaped as fish. Mere likeness captures the livingness of the thing before the lens. The blue light transforms the living thing into fixed idea and ideal, replication of something else. Mere likeness is not "like" anything else but itself and of itself, its mere being. The danger of its very reality begs for blue light, tranquilizing, transforming, deadening.

I
WAS CAUGHT
in my own bowels

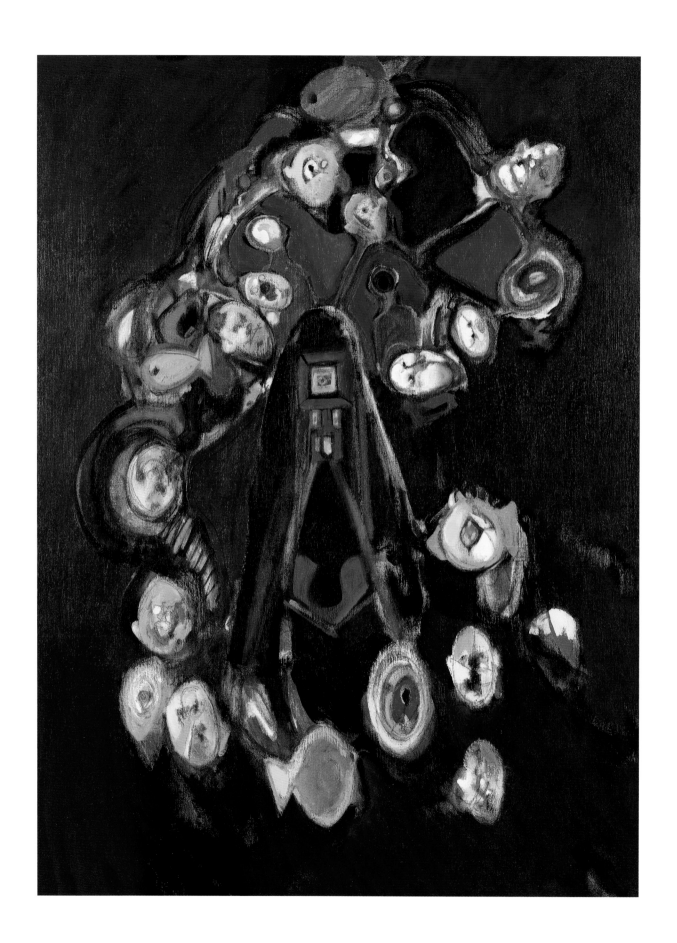

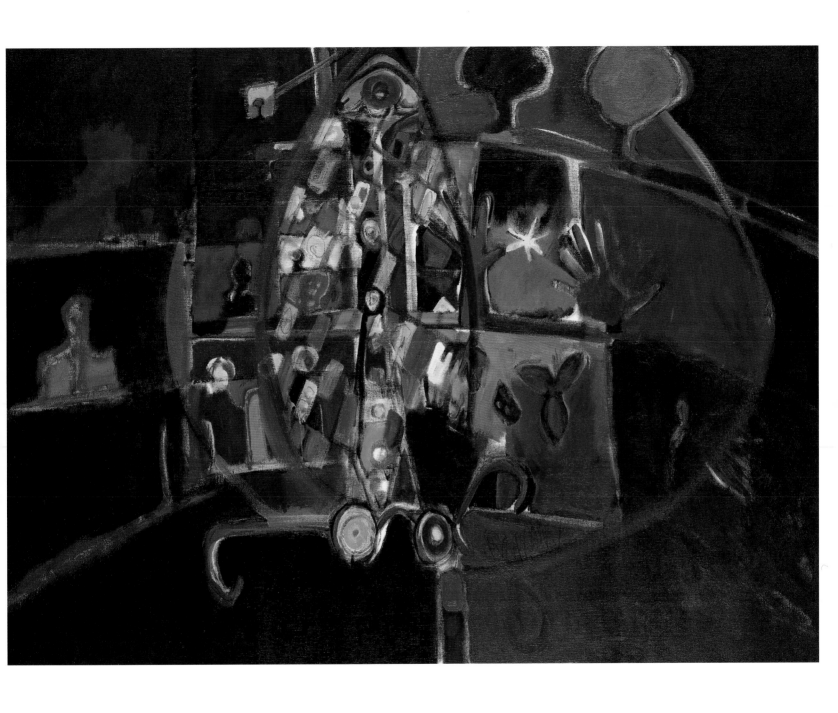

Left-Eyed Vision, 2006
oil on canvas, 46 × 62 inches

[opposite]
Death Surrounds My Camera, 2005
oil on canvas, 62 × 46 inches

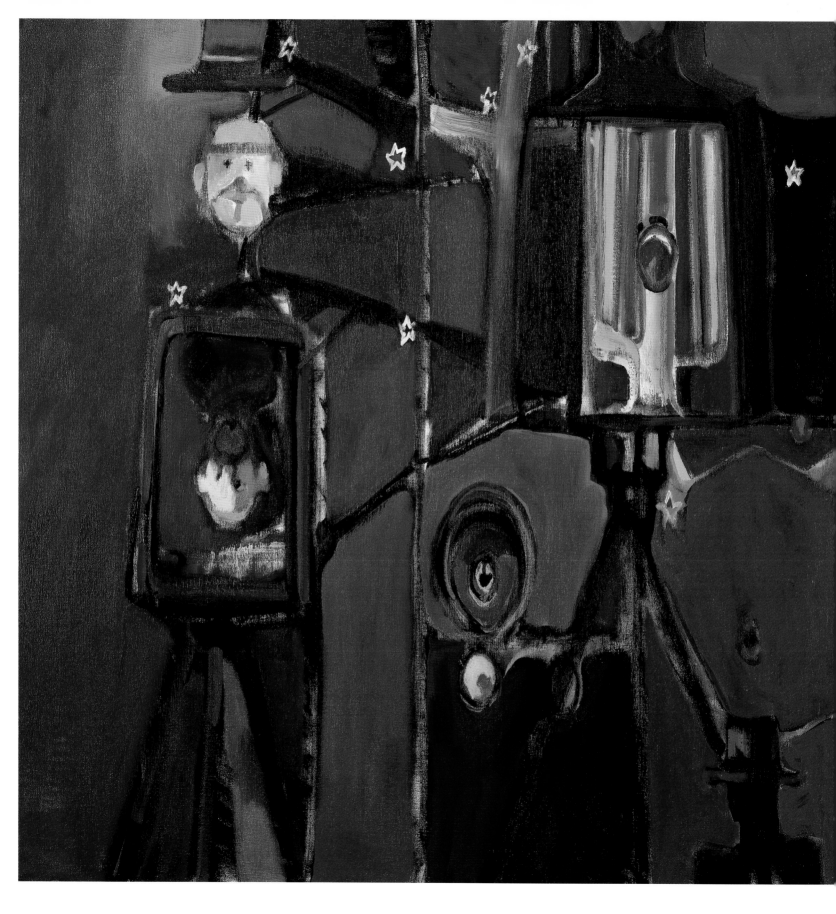

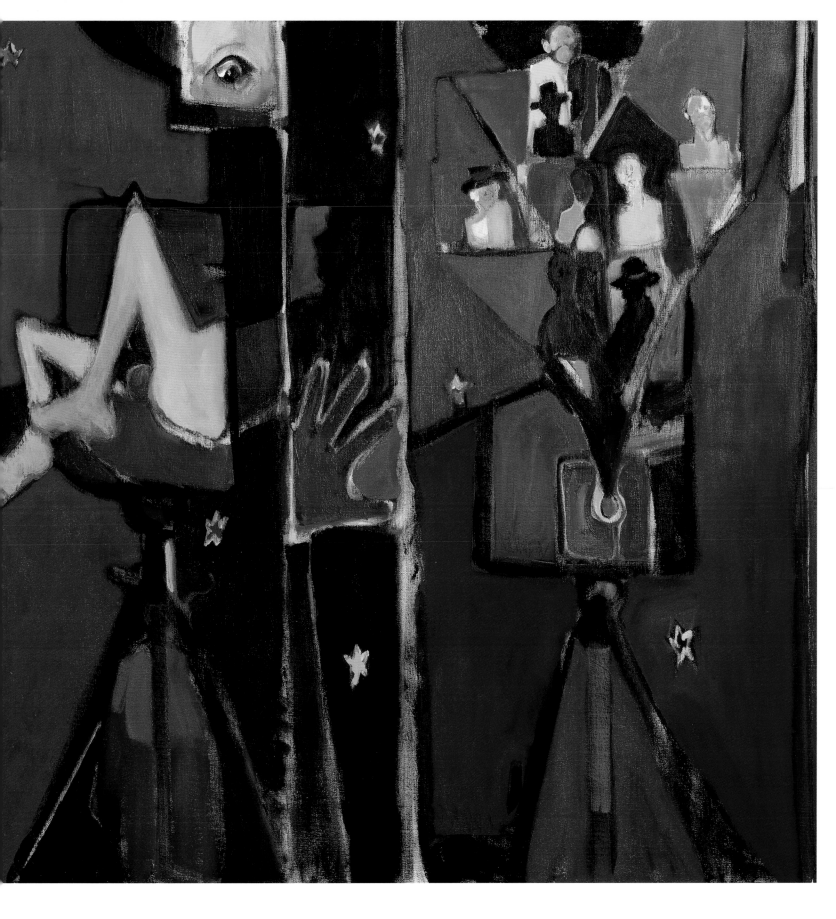

I was rarely
certain

[previous]
The Dialogue Between Mathew Brady & His Body (2 panels), 2005
oil on canvas, 50 × 100 inches

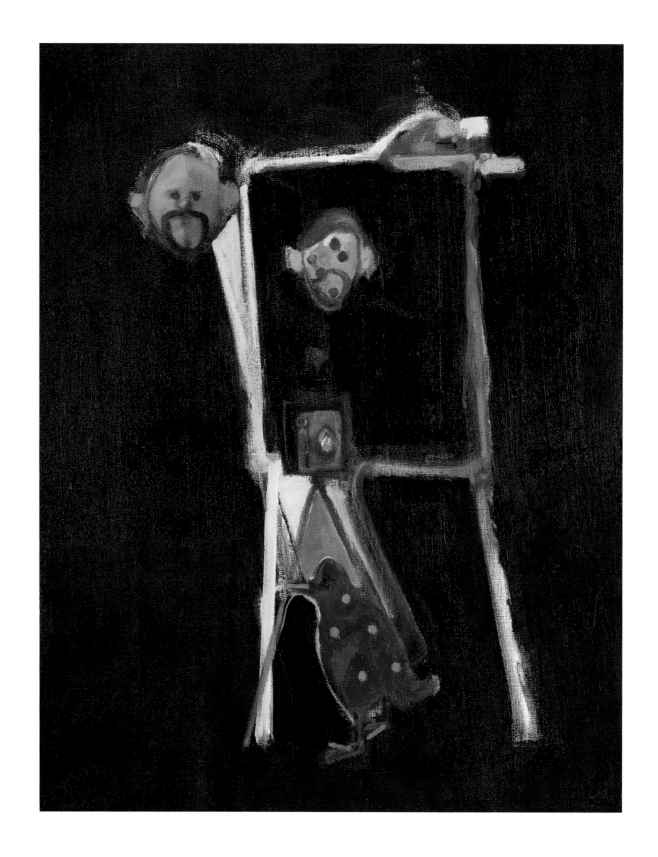

The Photographer, The Photograph, The Muse, 2006
oil on canvas, 38 × 30 inches

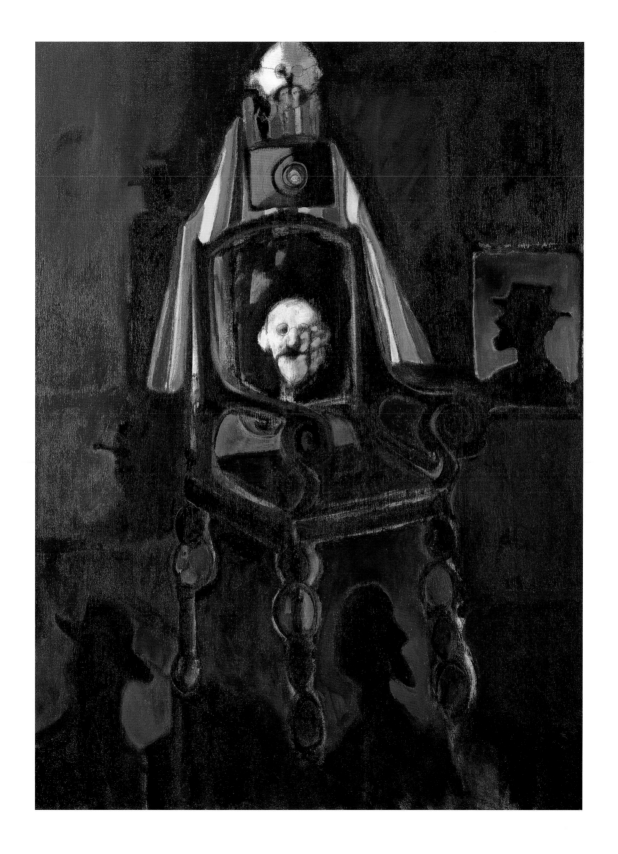

Chair as Self-Portrait, 2005
oil on canvas, 62 × 46 inches

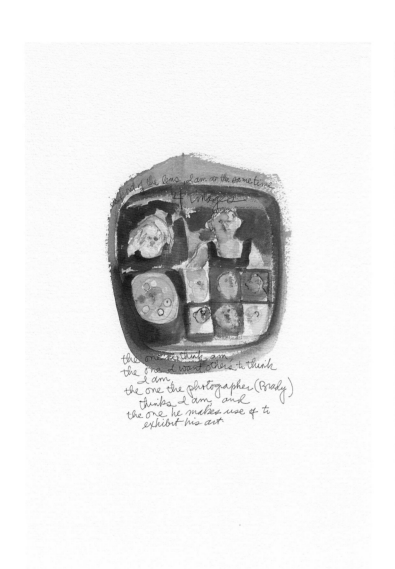

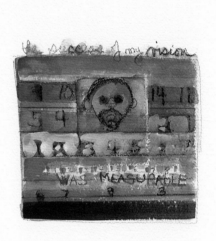

In front of the lens, I am at the same time
4 images
the one I think I am,
the one I want others to think
I am,
the one the photographer (Brady)
thinks I am, and
the one he makes use of to
exhibit his art.

the success of my vision
WAS MEASURABLE

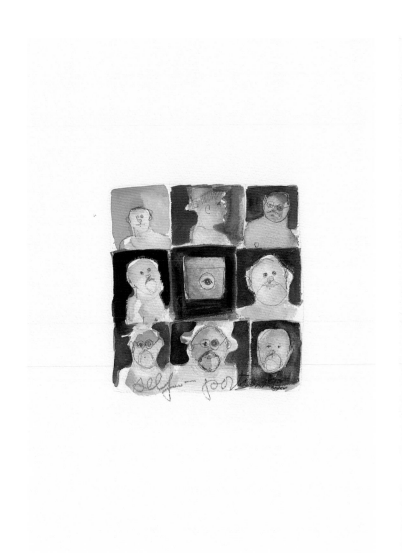

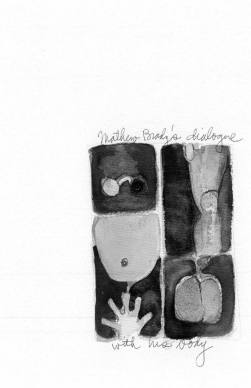

self-portrait

*Mathew Brady's dialogue
with his body*

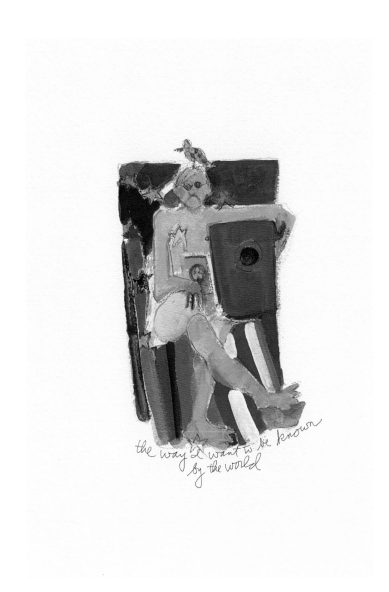

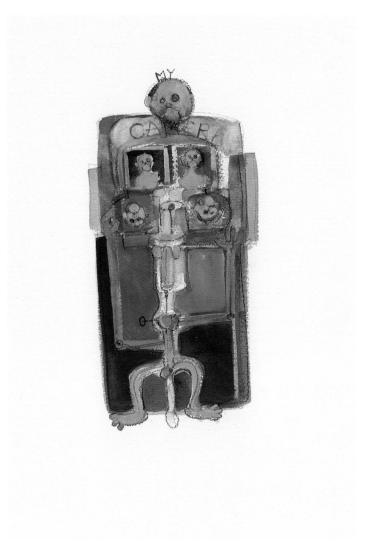

the way I want to be known
by the world

MY
CAMERA

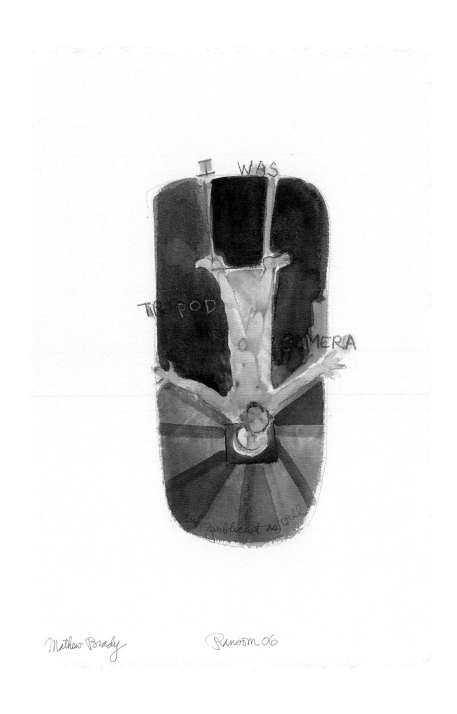

Mathew Brady Ransom 06

I WAS
TRIPOD
CAMERA
and publicist as well

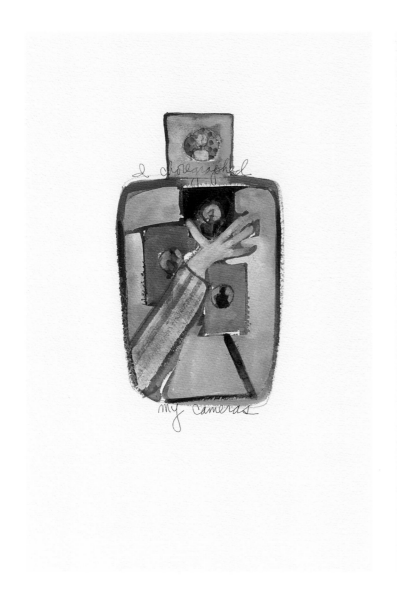

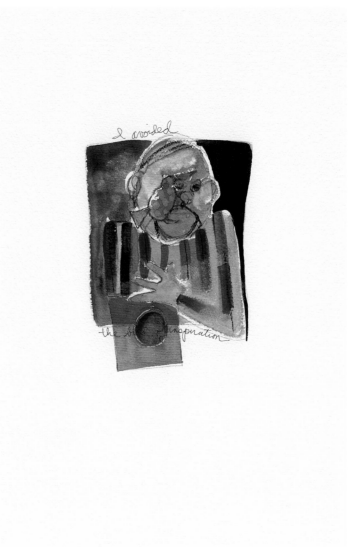

I choreographed
my cameras

I avoided
the bird of inspiration

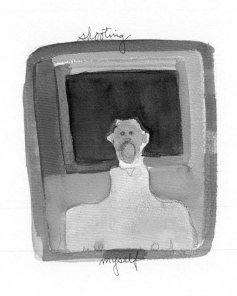

shooting
myself

untitled

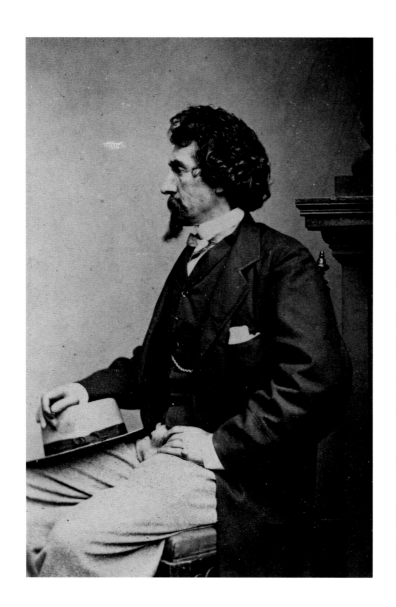

*the photographer's
organ is not his
eye but his finger.*

these are not my hands

*I concealed my left hand
because this part of my
body was disconnected
from my seeing right eye
and the seeing hand that
clicked the shutter.*

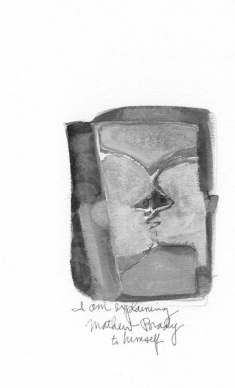

I am explaining
Mathew Brady
to himself

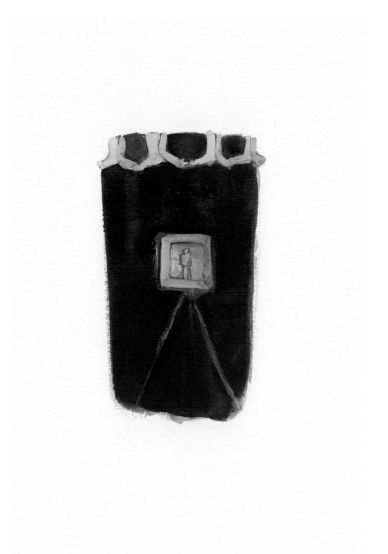

untitled

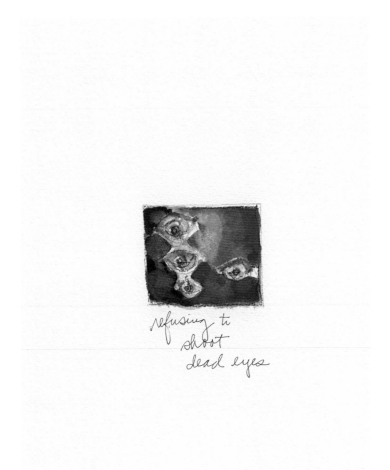

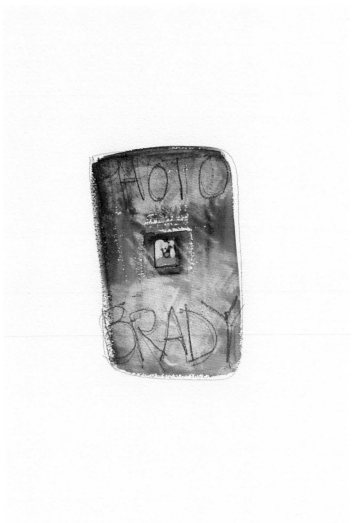

refusing to
shoot
dead eyes

PHOTO by BRADY

self portrait

my false door

untitled

untitled

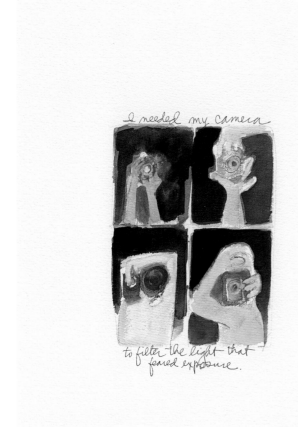

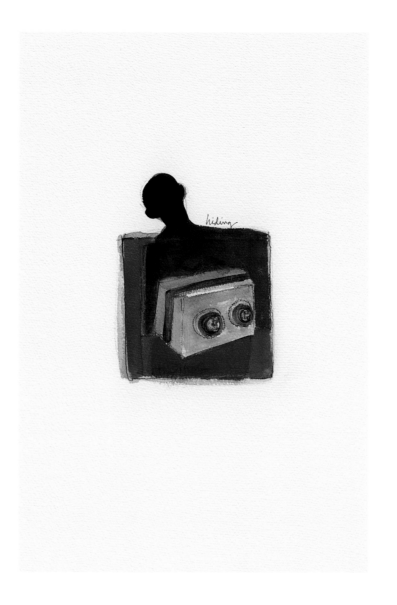

I needed my camera
to filter the light that
feared exposure.

hiding

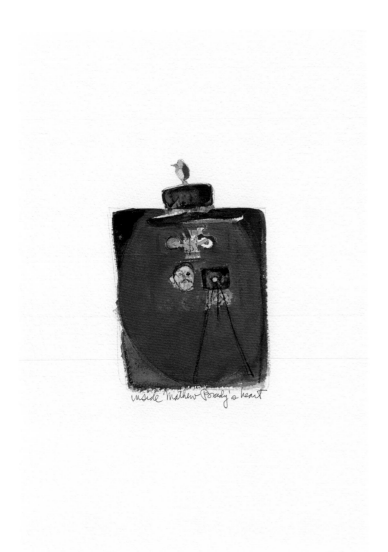

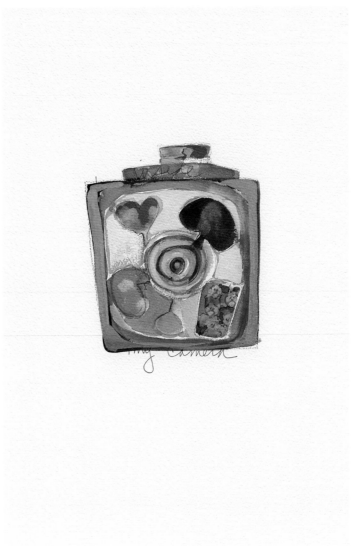

inside Mathew Brady's heart

inside
my camera

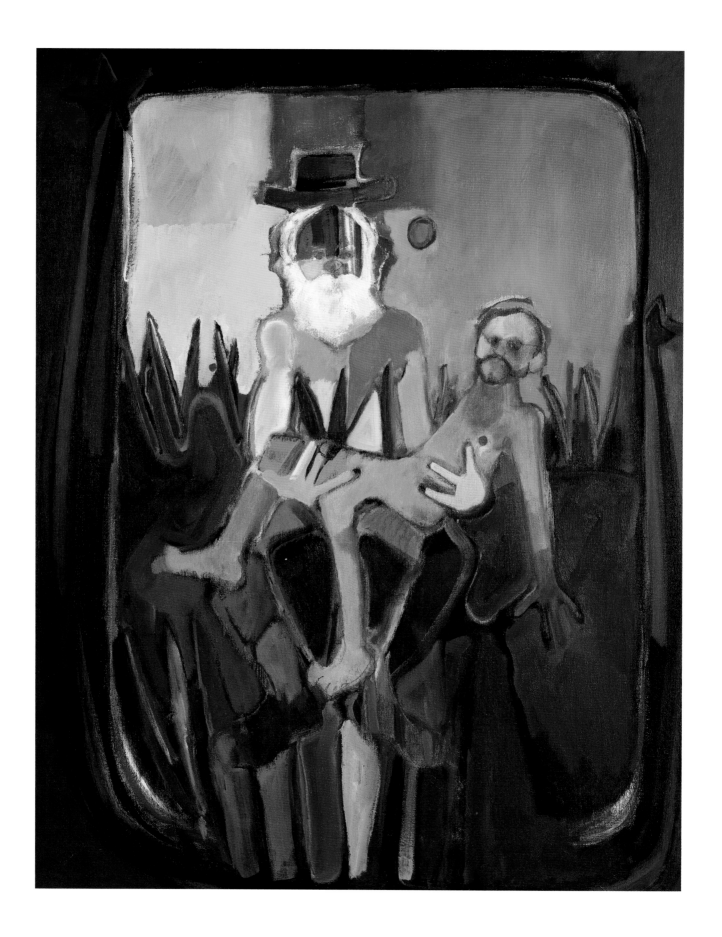

"Ah! what tales might those pictures tell . . . !"

Old Walt, white beard dripping like water, bears in his arms the wounded Brady (opposite page). See the blood spot over his heart—pietà in a comic mode. Brady stripped of "Broadway" looks small, funny, and sad. Both figures look toward the camera, toward us; we are their "you." They pose in the nude as if rising together from the summer grass. They make an indelible impression. A stunning painting, this extraordinary image signals a key moment in the ransoming of Mathew Brady.

In Phillips's story it is Walt Whitman who saves Mathew Brady, prepares him for ransoming, his return from the dead. The painting conveys what a complicated thing Phillips sees their relationship to be. Not to be missed is the wit of his perception. Wit pervades Phillips's work, not mere cleverness but honest humor, knowing nods at comic pretense and exaggeration, the occasional belly laugh at bizarre juxtapositions, the pleasure of finding unexpected harmonies in dissonance of color and clashes of hue. In this canvas Whitman is clearly the stronger, the saving figure. But they are surely allies.

Adjacent watercolors expose hidden facets of the relationship. Antagonistic: "What is commonest, cheapest[,] nearest, easiest is Me[.] I am an antidote to Mr. Brady" (right). Comradely: "Meeting Brady on the common ground of American illustriousness[.] Come to us on equal terms. Only then can you understand us. We are not better than you, What we enclose, you enclose, What we enjoy you

What is commonest, cheapest
nearest, easiest is Me
I am an antidote to
Mr. Brady

[opposite]
Walt Whitman Holding Mathew Brady, 2005
oil on canvas, 62 × 46 inches

*the functions of photography
to inform, to represent
to surprise, to cause to signify,
to provoke desire.*

*Photography photographs the notable
but soon, by a familiar
reversal, it decrees notable
whatever it photographs*

may enjoy" (this page). Both of these watercolors are quickening paintings, as if the freshness of their original wetness were still upon them. Other images similarly display a kind of love between the older and the younger man (Whitman no more than four or five years older, yet seeming ageless besides the child-man Brady). They exist here as if in suspended dialogue.

"I have it: Brady! Brady!" Whitman's creaking voice exclaimed one evening in 1889 in his Mickle Street house in Camden. He was browsing old photographs of himself, a favorite pastime. When his visitor said "we might some day have a W. gallery," the forgotten name flashed back.

> What you have just said brought into my mind
> certain hours, talks of the old times—with them
> Brady's name. . . . Brady had galleries in Washing-
> ton: his headquarters were in New York. We had
> many a talk together: the point was, how much
> better it would often be, rather than having a lot
> of contradictory records by witnesses or historians
> —say of Caesar, Socrates, Epictetus, others—if we
> could have three or four or half a dozen portraits—
> very accurate—of the men: that would be history—
> the best history—a history from which there
> would be no appeal.[18]

Was that Brady's notion? "No: mine, I suppose: I suppose I spun that out—reeled it off: but I know that we discussed it—that it was occasioned by conversations we had together."[19]

Brady and Whitman conversing on history and photography: this is an actual memory recorded by Horace Traubel, the old poet's ardent young Philadelphian friend. Whitman

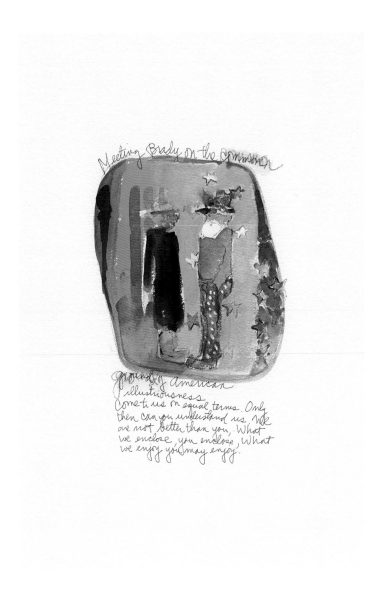

*Meeting Brady on the common
ground of American
illustriousness
Come to us on equal terms. Only
then can you understand us. We
are not better than you, What
we enclose, you enclose, What
we enjoy you enjoy.*

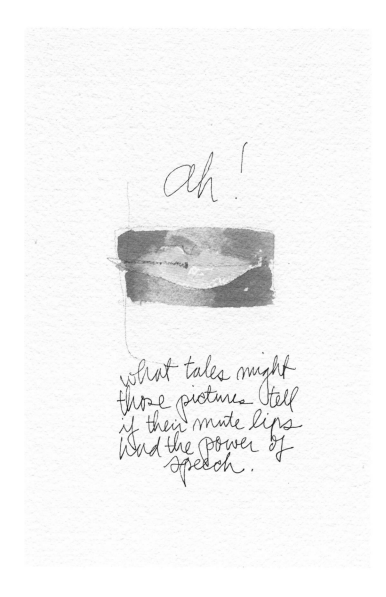

Ah!
what tales might
those pictures tell
if their mute lips
had the power of
speech.

had doubtless met Brady in the late 1840s and 1850s when, as man-about-town and journalist for Brooklyn papers, he roamed lower Manhattan and reported on art exhibitions, new buildings, Broadway crowds, streetcars, curiosities such as Dr. Abbott's Museum of Egyptian Antiquities,[20] and the new photo-portrait galleries. In 1846 he had singled out "Mr. B" for special mention:

> By the bye, Mr. B. is a capital artist, and deserves every encouragement. His pictures possess a peculiar life-likeness and air of resemblance not often found in works of this sort. —His portraits of several well known characters at the corner always attract attention. I commend him to your Brooklyn gentry.[21]

In the *Brooklyn Eagle* in the same year Whitman again evoked "peculiar life-likeness": "What a spectacle! Ah! what tales might those pictures tell if their mute lips had the power of speech!"[22] (Is this a clue to his barely remembered conversation with Brady?) Such pictures create "the impression of an immense Phantom concourse—speechless and motionless, but yet realities. You are indeed in a new world—a peopled world, though mute as the grave." And further, "Time, space, both are annihilated, and we identify the semblance with the reality."[23] Semblances or likenesses or copies made to seem real, mute speech makes it seem that even silence speaks: the telling paradoxes make the point.

Unlike Brady, Whitman celebrates mere likeness. Rather than wishing to disguise likeness as illustriousness or enshrining American men of destiny much "like Roman household gods" (p. 88, bottom right), Phillips's Whitman saw photography as promotion of desire, ecstasy, erotic

encounter, as "presence" achieved by a dialectical encounter with mere likeness: "not the picture or representation reveals the self—but the questioning of the picture, the touching of it, the effort to imagine what lies behind it, antecedent to it" (right). The watercolor that bears this inscription shows a young beardless Whitman—the marvelous hat gives him away—a divine, almost foolishly happy look on his beautiful face. Phillips's Whitman takes likeness to be a sign of death, the body like everything natural subject to decay and death. "Photography is a kind of primitive theater," the poet observes in another striking watercolor, "a figuration of the motionless and made-up face beneath which we see the dead" (p. 122, left).

"The dead are brought back to life here," wrote one newspaper account of the Brady gallery, "so faithfully and so perfectly that those who knew them in the flesh can scarcely fail to recognize the impress of their shadows on the magic glass."[24] Brady's delusional dream was that in that glass the Republic could view itself as in the mirror: "From the rude forefathers of the country, to the men who built up the superstructure of the republic on the foundations which they laid, and down to the men of the present day, when our power is spreading abroad with electric speed."[25] Enshrining national icons as household gods, the gallery performed a quasi-religious function in a republican culture that had overthrown a system of deference based on social station and birth. In the gallery calculation and competition might be imagined to cease momentarily. Here hung ghostly images more real and nurturing than the shadows flitting on the streets and in the marketplace, for they held out the hope of at least one certainty: an unmistakable historical self, a point of reference among phantoms. Brady's gallery of delusion offered itself as an alternative fantasy to

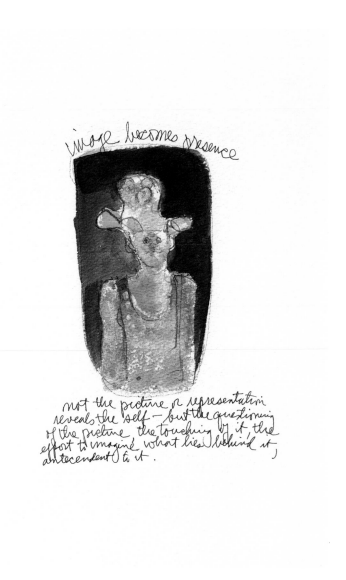

image becomes presence
not the picture or representation
reveals the self—but the questioning
of the picture, the touching of it, the
effort to imagine what lies behind it,
antecedent to it.

I have judged + felt

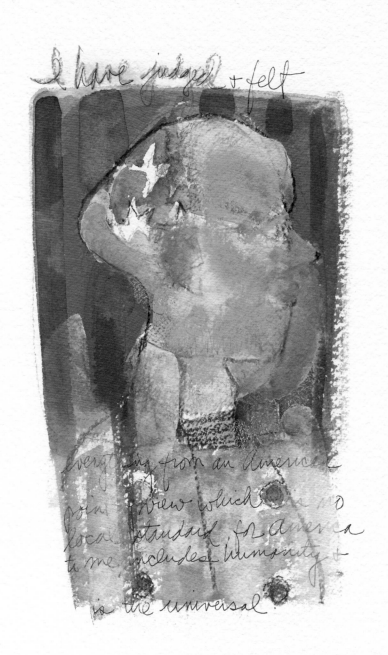

everything from an American
point of view which has no
local standard, for America
to me, includes humanity +
is the universal.

possessive individualism and the blight of egotism. Alexis de Tocqueville wrote: "not only does democracy make every man forget his ancestors, but it hides his descendents and separates his contemporaries from him; it throws him back forever upon himself alone and threatens in the end to confine him entirely within the solitude of his heart."[26] Brady might have known these words by heart, though the deeper resonance might have escaped him; they haunt his gallery of iconic American ghosts.

One way to understand "gallery of dead" is that anything other than "mere likeness," the naked unadorned camera account, deprives the subject of its life. Roland Barthes imagines that because they stop time and freeze images as they appeared at a fixed moment in the past, all photograph portraits show sitters as they will be seen after their death, as if they had already died at that moment of exposure.[27] In this sense the commonplace term "shoot" in connection with taking a picture becomes a wicked pun: to photograph is to kill. *Shooting the Dead* (pp. 22–23) shows the photographer within some sort of red protective enclosure as corpses surround his camera, naked bodies already dead subjected to another "shooting" as if to keep them dead. No clues in the painting suggest that this is a battlefield scene, but the painting's argument prepares for Brady's ambiguous role in the Civil War. Killing by shooting is not simply taking aim with the camera but begins even before that, by setting up and directing the scene of performance. *Photography as Performance* (pp. 132–37), presented with its five panels in six different combinations and orientations, is structurally the most ambitious of the oil paintings. It is also the most explicit, showing Brady not behind the camera but off to the side with a director's baton in his hand, giving orders to the figures in different

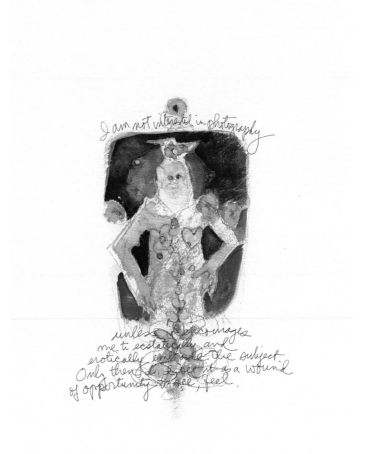

I am not interested in photography
unless it encourages
me to ecstatically and
erotically embrace the subject.
Only then do I see it as a wound
of opportunity to see, feel.

[opposite]
I have judged and felt
everything from an American
point of view which is no
local standard for America
to me, includes humanity and
is the universal.

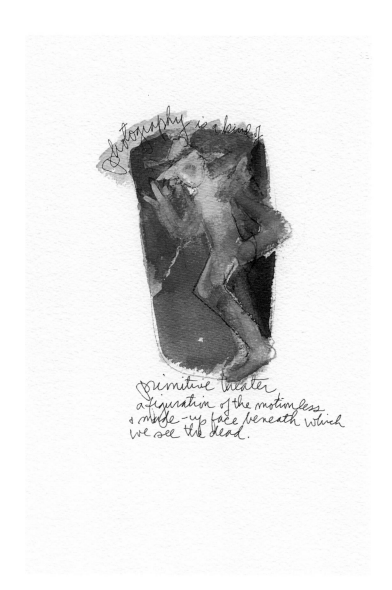

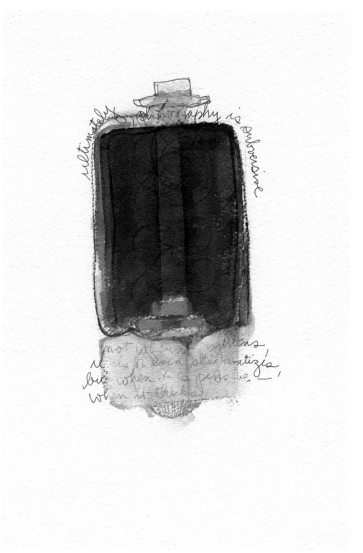

Photography is a kind of
primitive theater,
a figuration of the motionless
and made-up face beneath which
we see the dead.

ultimately, photography is subversive
not when it frightens,
repels or even stigmatizes,
but when it is pensive—
when it thinks

arrangements within the curtained area of the studio-stage. These are awesome paintings, dazzling and dizzying in their colors, their defiance of gravity, their spatial complications. Here is Brady in his studio controlling the scene. Here we see camera and baton as instruments of power, delusional power that confines Brady to the role of illusion-maker as securely as it imposes deadening roles on his sitters.

Brady's genius was to grasp instinctively the pleasure and the profit of role-playing, of becoming *like* something else, a copy, not yourself *merely* but yourself provisionally or virtually, a pose or guise to which you are linked by subtle ties of association. "My gallery," Phillips has him explain, "was no ordinary place but a theater of desire; a site in the city devoted to performance where you experienced the make-over of yourself into an image of social power and success" (p. 73). Brady understood with Aristotle that art is imitation, illusion, stagecraft, images cast in stone, on glass, canvas, paper,[28] and gives no exemption for sun-based images captured in a camera; to the contrary, those brilliant mirror-like light images on metal or paper proved the point. For Plato the idea of imitation or "resemblance," as he explained in *The Republic*, was utterly delusional, as if a copy could ever come close to a real thing or even reliably point to it.[29] Brady straddled Aristotle and Plato, made copies he knew were copies and hence unpersuasive. Yet his images commanded belief insofar as they gave off the lustrous glow of America as sacred calling. He understood theatre and stagecraft, yet could say to himself (in Phillips's words) both that "photos were real objects to me" (p. 48, left) (the past tense reveals that he's already ransomed) yet "all my subjects merged and became a vapor" (p. 140). He knew well enough to craft the necessary illusions, but not well enough to foresee the consequences: galleries and fields of dead.

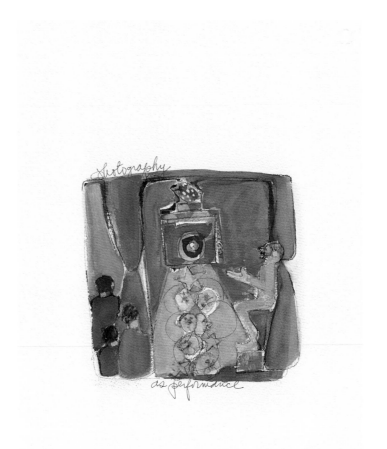

photography as performance

shooting
red grass

leaves of grass

grass bed

where their priceless
blood reddens the grass
the ground

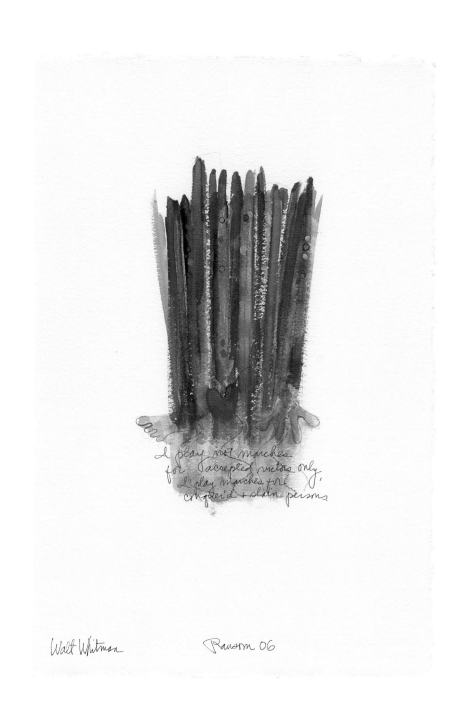

Walt Whitman Ransom 06

I play not marches
for accepted victors only,
I play marches for
conquer'd and slain persons.

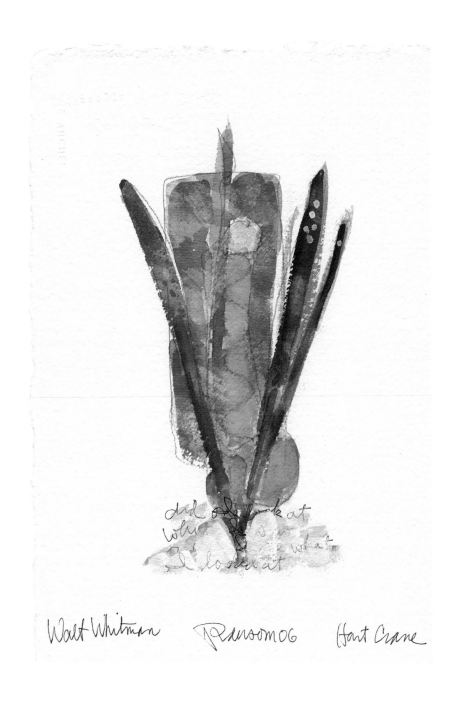

did ~~one~~ *I look at*
what ~~one~~ *I saw*
or did ~~one~~ *I see what*
I looked at

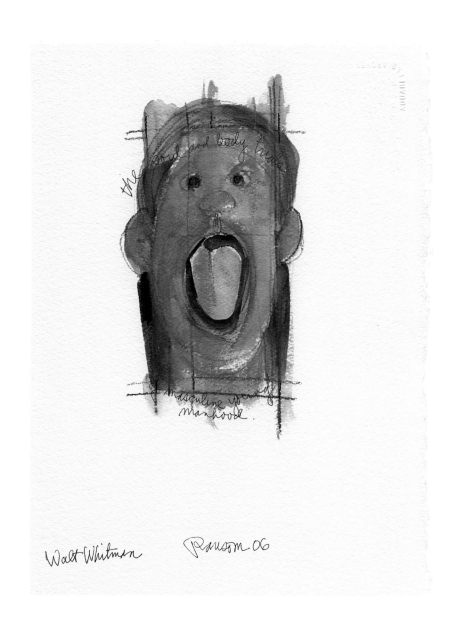

Walt Whitman Ransom 06

the soul and body trials
of masculine young
manhood.

Walt Whitman Ransom 06

Young Man
I think I
know you
Who are you sweet
boy with cheeks
of blooming?

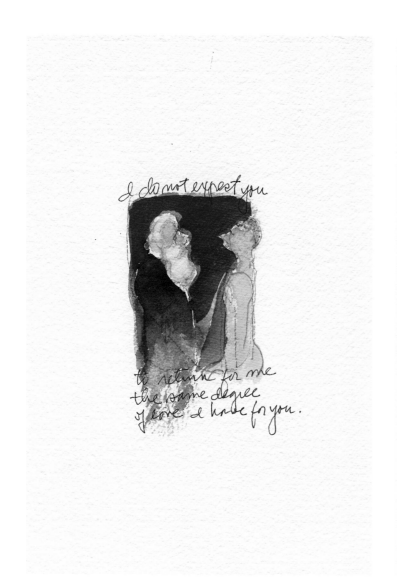

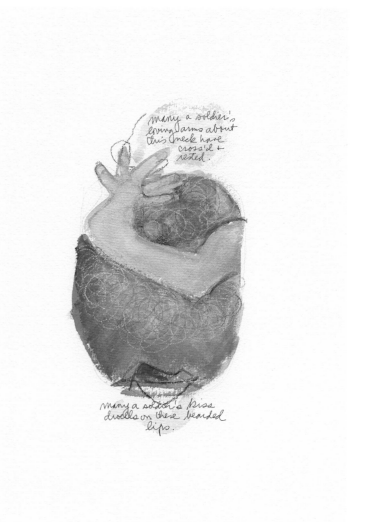

I do not expect you
to return for me
the same degree
of love I have for you.

many a soldier's
loving arms about
this neck have
cross'd and
rested.
many a soldier's kiss
dwells on these bearded
lips.

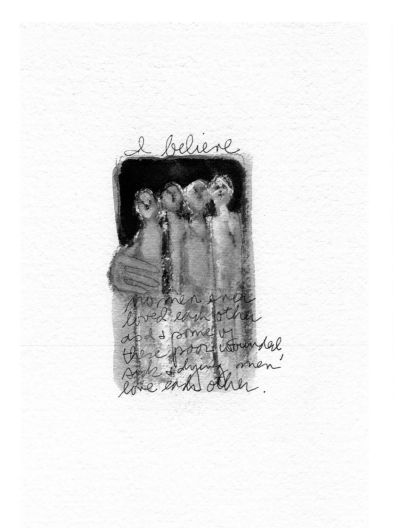

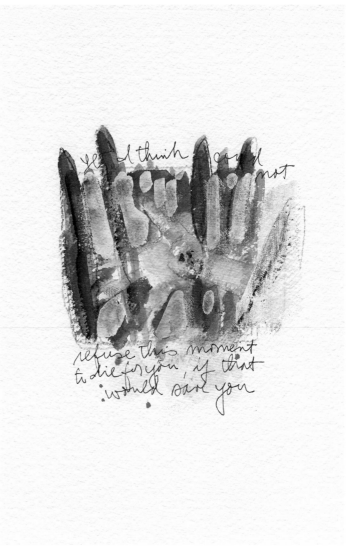

I believe
no men ever
loved each other
as I and some of
these poor wounded,
sick and dying men
love each other.

yet I think I could not
refuse this moment
to die for you, if that
would save you

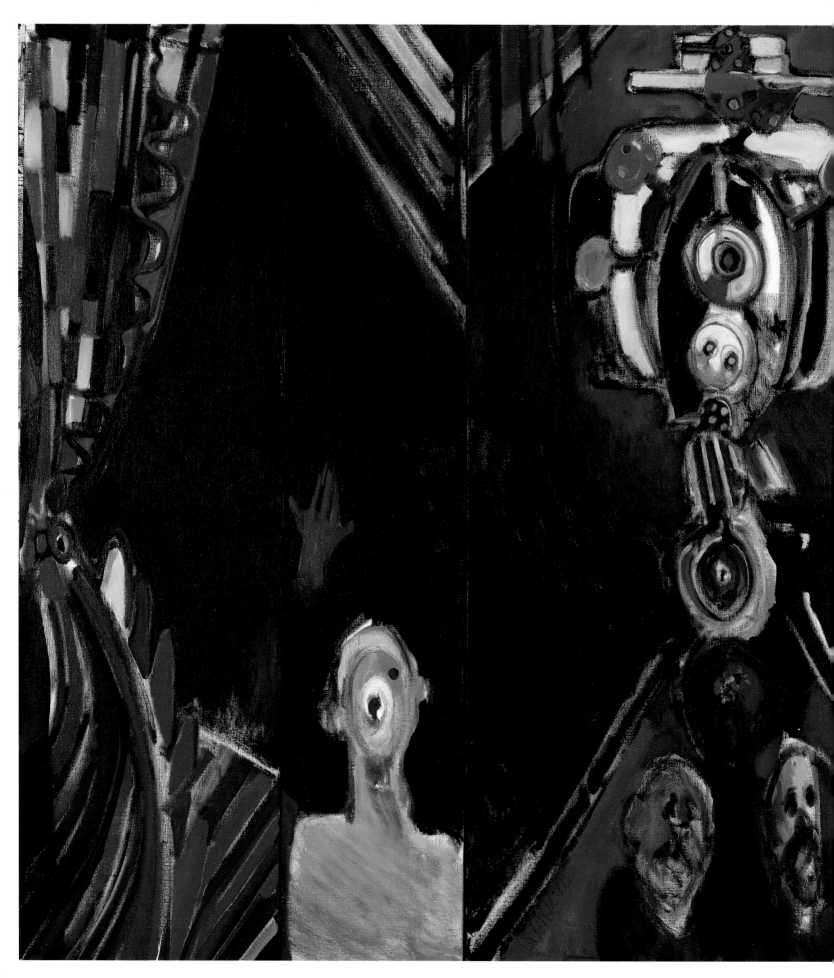

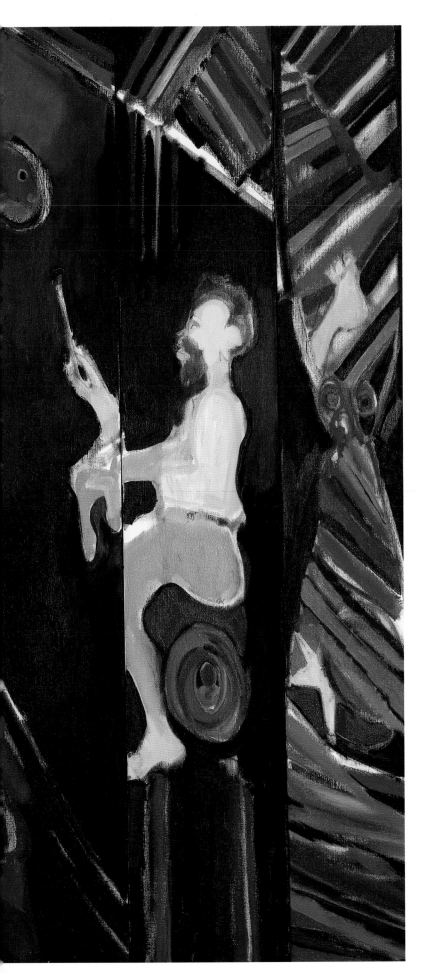

Photography as Performance (5 moveable panels, var. 1), 2006
oil on canvas, 70 × 94 inches overall

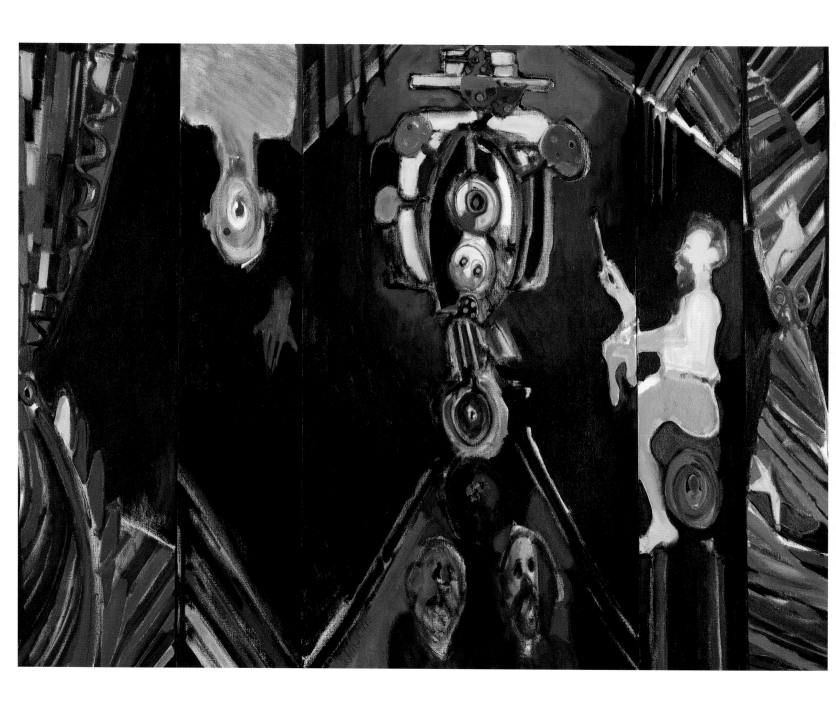

Photography as Performance (var. 2)

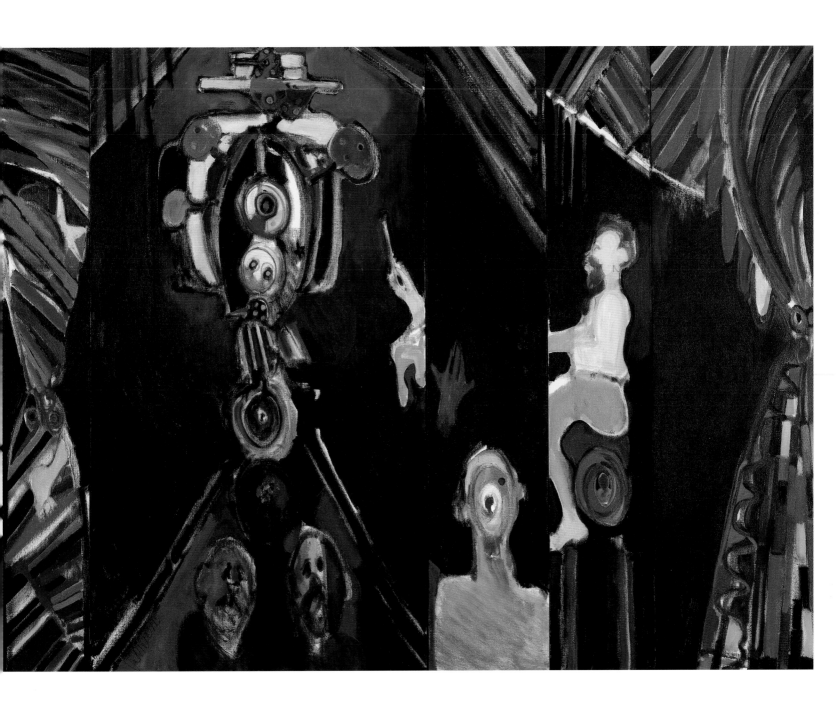

Photography as Performance (var. 3)

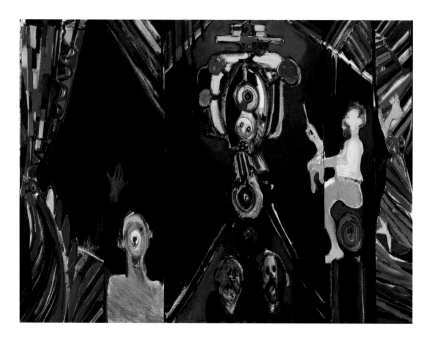 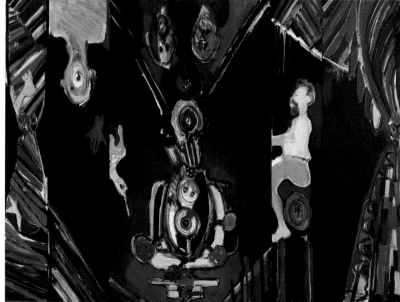

Photography as Performance (var. 4, 5)

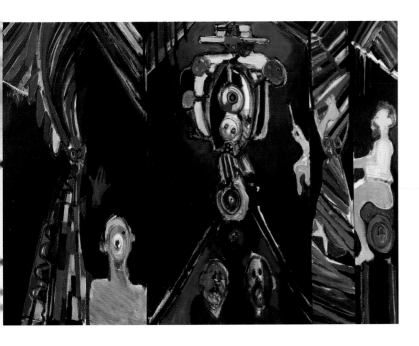
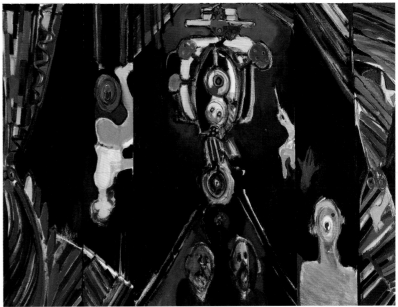

Photography as Performance (var. 6, 7)

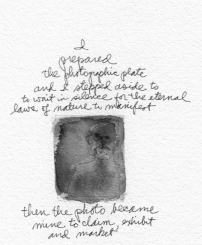

I
prepared
the photographic plate
and I stepped aside to
to wait in silence for the eternal
laws of nature to manifest
then the photo became
mine to claim, exhibit
and market

the backs of photographs

Mathew Brady Ransom 05

untitled

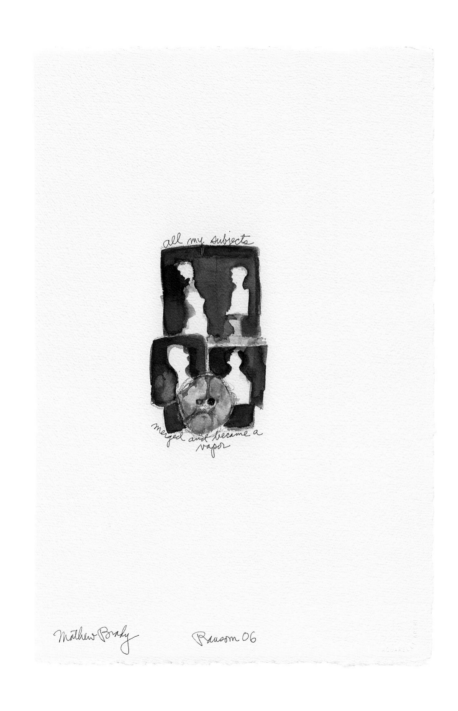

all my subjects
merged and became a
vapor

Mathew Brady Ransom 06

all my subjects
merged and became a
vapor

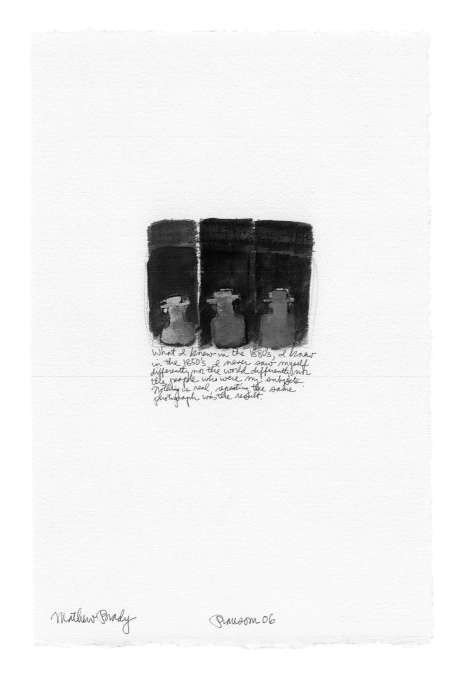

Matthew Brady Ransom 06

What I knew in the 1880's, I knew
in the 1850's. I never saw myself
differently nor the world differently nor
the people who were my subjects.
Nothing is real, repeating the same
photograph was the result.

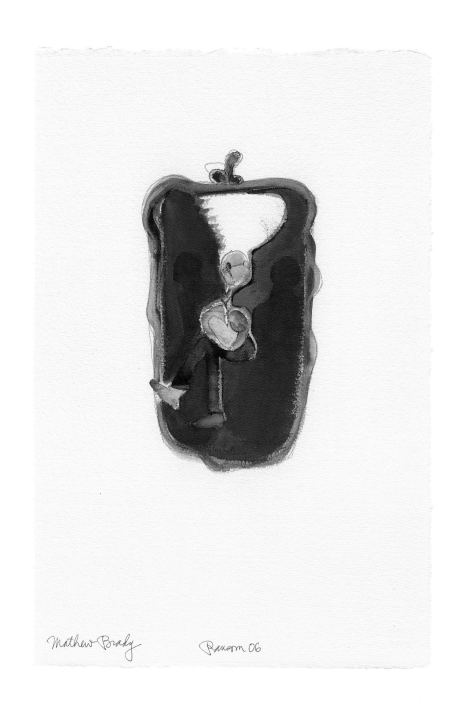

Mathew Brady Ransom 06

untitled

ultimately I shot blankness

which is blackness duplicated,
shuttered and exposed.

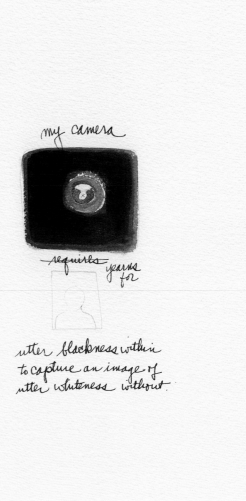

my camera

~~requires~~ yearns for

utter blackness within
to capture an image of
utter whiteness without.

ultimately I shot blankness
which is blackness duplicated,
shuttered and exposed.

my camera
~~requires~~ yearns for
utter blackness within
to capture an image of
utter whiteness without.

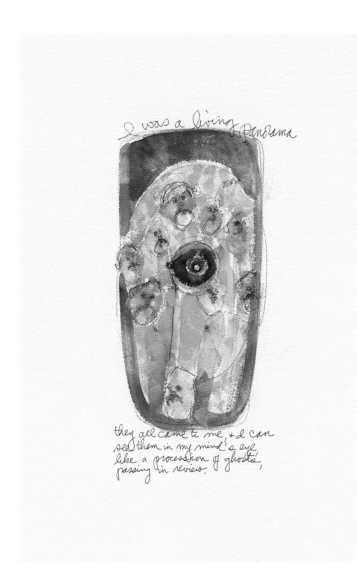

I was a living panorama

they all came to me, & I can see them in my mind's eye like a procession of ghosts, passing in review.

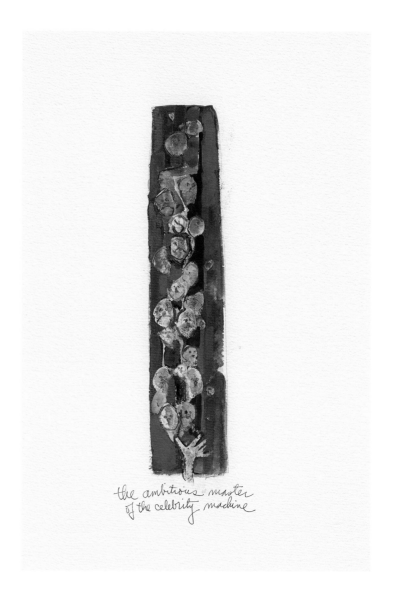

the ambitious master of the celebrity machine

I was a living panorama
they all came to me, and I can
see them in my mind's eye,
like a procession of ghosts,
passing in review.

the ambitious master
of the celebrity machine

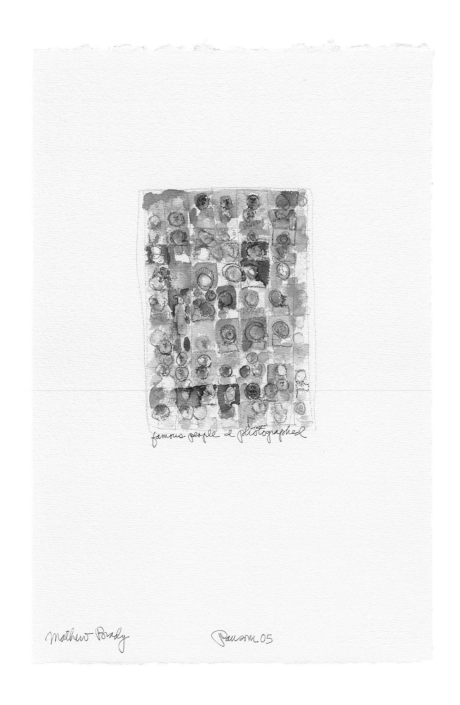

famous people I photographed

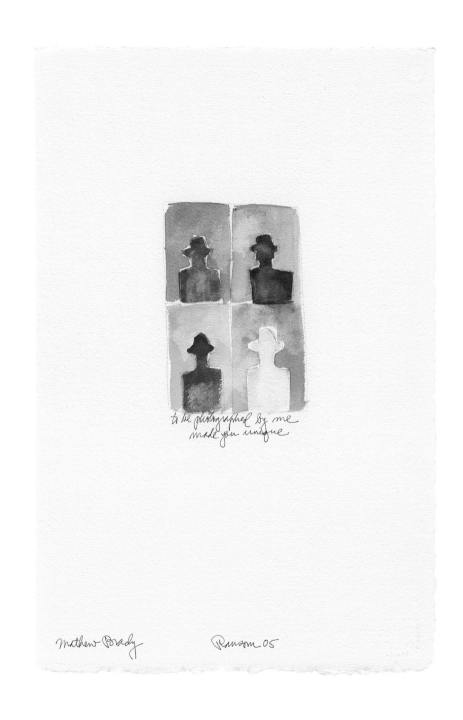

to be photographed by me
made you unique

was immediate

Mathew Brady Ransom 06

my success
was immediate

nature
imitates ~~art~~
idea

Mathew Brady
smoking a
daguerrotype

Mathew Brady Ransom 06

BLACK and WHITE

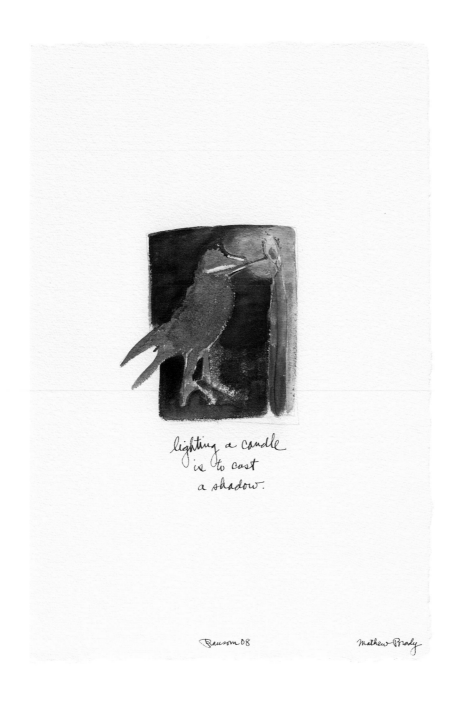

lighting a candle
is to cast
a shadow.

Ransom 08 Mathew Brady

lighting a candle
is to cast
a shadow.

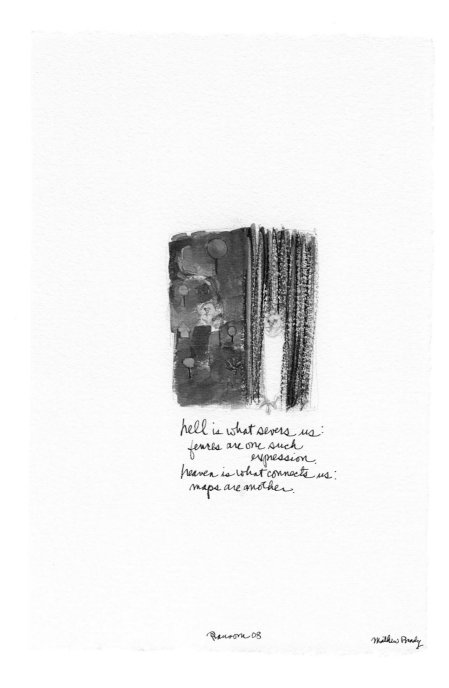

hell is what severs us:
fences are one such
expression.
heaven is what connects us:
maps are another.

*Can I distort
an idea knowing
it can have a
greater impact on
what is real?
tell the truth, but
tell it slant.*

for Emily Ransom 08 Mathew Brady

Can I distort
an idea knowing
it can have a
greater impact on
what is real?
tell the truth, but
tell it slant.

for Emily

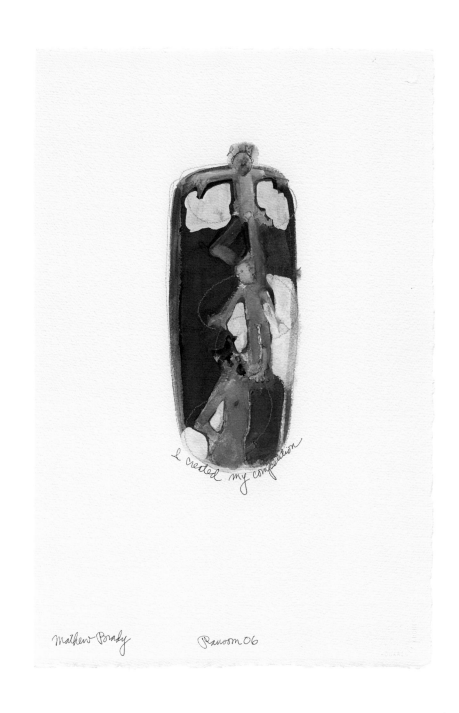

I created my competition

Mathew Porady Ransom 06

TIM
ALEX
I created my competition

Mathew Brady Ransom 06

what you see is not
mine
but claimed by me

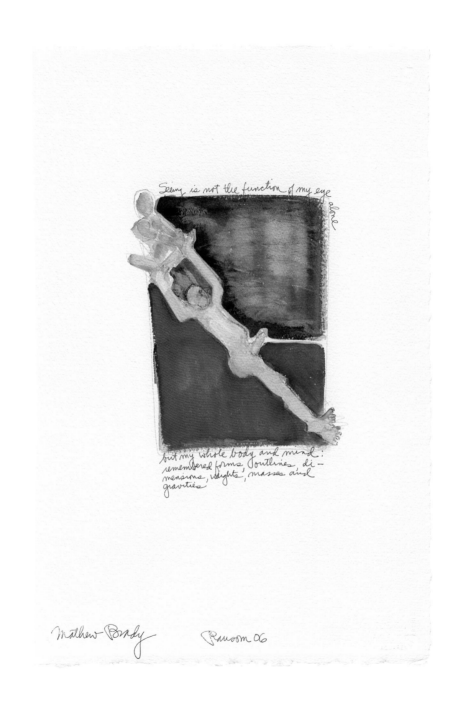

Seeing is not the function of my eye alone
but my whole body and mind:
remembered forms, outlines, di-
mensions, weights, masses and
gravities

Mathew Brady Ransom 06

I understand all too well
that as photography
withdrew from portraiture
its function changed: now
photos became standard
evidence for historical
occurrences and for information

*I day-dream that
metaphors are erotic
forces that bridge
heaven + hell,
love + hate,
casting deep shadows
in even deeper light.*

Ransom 08 Mathew Brady

*I day-dream that
metaphors are erotic
forces that bridge
heaven and hell,
love and hate
casting deep shadows
in even deeper light.*

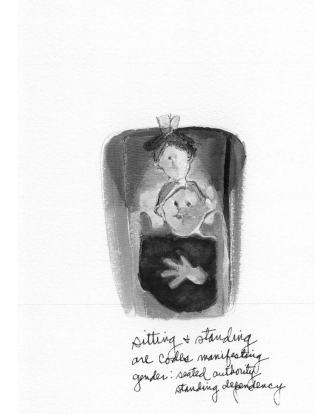

sitting & standing
are codes manifesting
gender: seated authority
standing dependency

hands held
heads linked

has yielded for me a
generic standard,
a codified way
of depicting affection.

sitting and standing
are codes manifesting
gender: seated authority
standing dependency

hands held
heads linked
has yielded for me a
generic standard,
a codified way
of depicting affection.

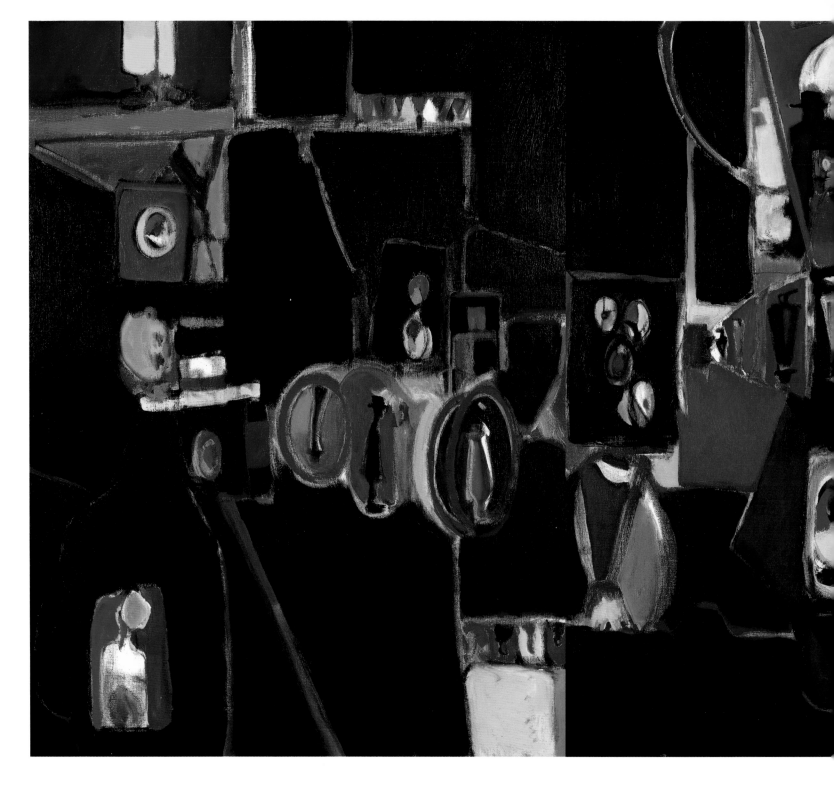

Shooting (3 panels), 2007
oil on canvas, 62 × 144 inches overall

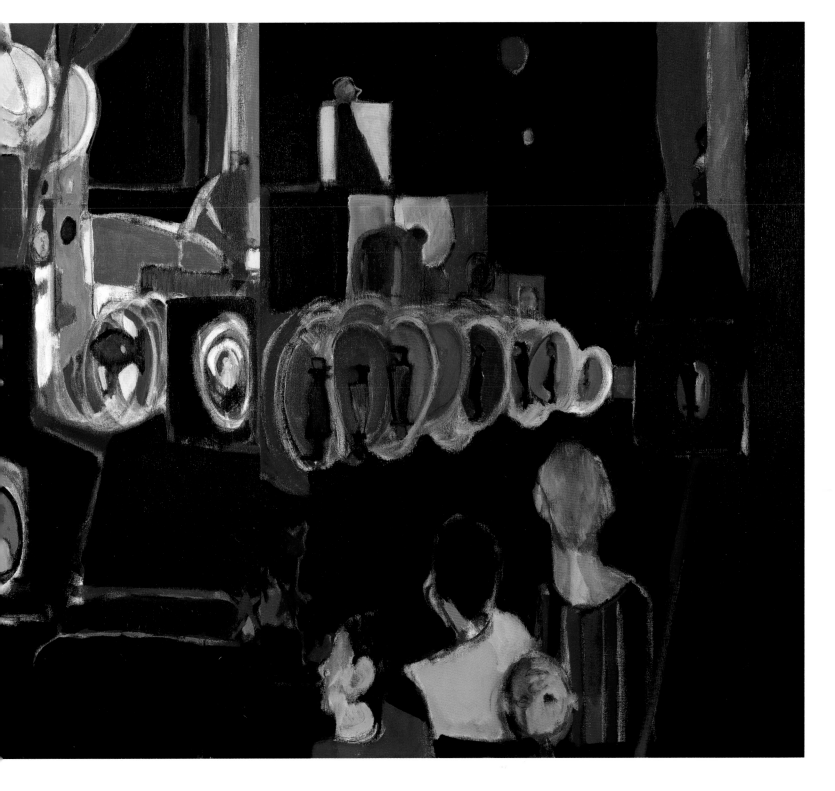

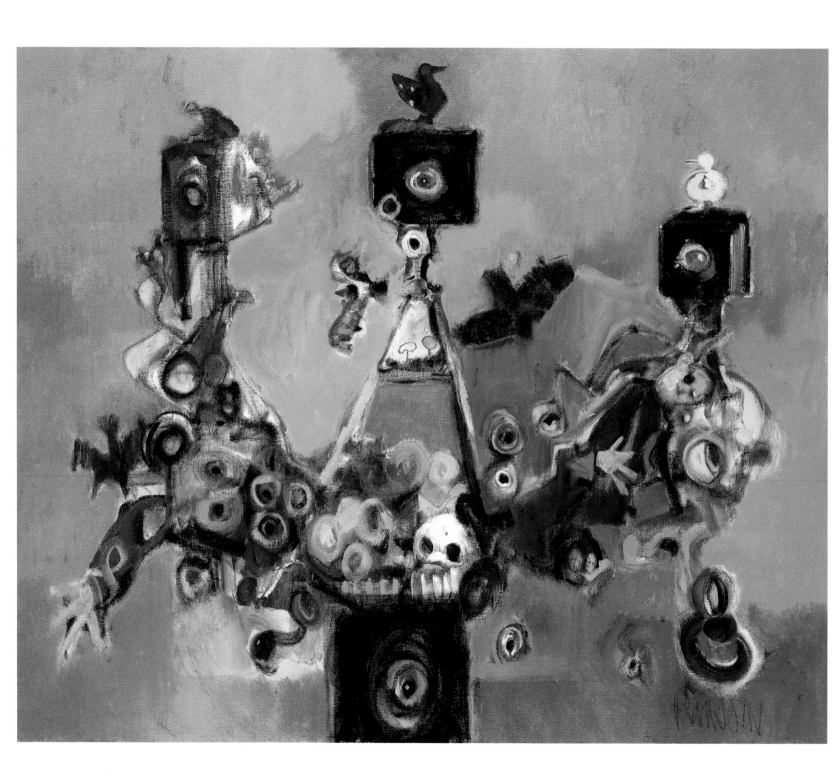

Raising the Dead

———→ •• ←———

"What like a bullet can undeceive?"

Herman Melville, "Shiloh"

But who could foresee? "Who here forecasteth the event?" Herman Melville asked in "The March into Virginia Ending in the First Manassas (July, 1861)." In the spirit of a "berrying party," in Melville's ironic words, or a "picnic party in . . . May," jolly American crowds dashed from Washington to enjoy the expected sight of an easy Union victory at Bull Run (the First Battle of Manassas). And the young soldiers too:

Into that leafy neighborhood
In Bacchic glee they file toward Fate,
Moloch's uninitiate. . . .
So they gayly go to fight,
Chatting left and laughing right.

The mood could not last nor the innocence:

[S]ome who this blithe mood present, . . .
shall die experienced ere three days be spent—
Perish, enlightened by the vollied glare. . . .

That terrible image of innocence perishing from too much light, enlightenment through fatal bombardment, still haunts American consciousness of the Civil War, of any war to which young soldiers march as if to play. "Enlightened by the vollied glare": the paradox is founded on the unspeakable visual fact—the reality that cannot be spoken—of what exploding shells do to human bodies and what fields of battle reveal when the smoke clears.[30]

"The real war," Whitman wrote famously in *Specimen Days* (1882), "will never get in the books. . . . Future years will never know the seething hell and the black infernal background of countless minor scenes and interiors (not the official surface-courteousness of the Generals, not the few great battles) of the Secession war; and it is best they should not."[31] Something

[opposite]
Shooting Eyes, 2007
oil on canvas, 50 × 60 inches

open wound

Mathew Brady Ransom 05

inexpressible lies buried in the war's "lurid interiors." "In the four years of war millions of Americans really hated one another and really wanted to kill one another," wrote historian Oscar Handlin in 1961. "The drama they acted out on the battlefields was less one of gallantry and courage than of hatred."[32] Nurtured on "Illustrious Americans" and belief in the magical virtue of republican portraiture, those who took Brady's camera performances as the real thing set themselves up for volleys of enlightening glare. Nothing like a bullet to undeceive.

With a wagon full of camera equipment Brady joined the berrying excursion to Bull Run. During the ensuing inglorious retreat he was lost in the woods for three days, returned to Washington, and immediately took his own picture in his disheveled duster and familiar hat. He had been there, and had some negatives of "grim-visaged war," in the words of one journal, "further to prove it."[33] The retreat may have been a good thing for Brady, for in truth he could not abide the sight of death, especially bloated, stinking corpses of soldiers murdered in battle. It is evident from several pictures of Brady in the fields of war that he averted his eyes. "I arrived late at the battlefield," he explains in a watercolor (p. 177); he faces forward as if toward a camera, behind his back a field of muted reds, whites, and blues. "The unpleasantness was gone," he writes, "no death, but reflection and quiet. [It] is the look of landscape where history was made. [Y]ou are seeing what I am seeing. I preceded you." He was, he admits in another watercolor, "afraid to see horror" (p. 79), and waiting until unpleasant facts of death and dismemberment were "gone," he shared reprieve with his viewers.

Brady placed himself as the contemplative figure in apparently tranquil landscapes perhaps as much to spare his viewers as himself. Reactions in the press to pictures made on some of the bloodiest fields of the war may have shaken his confidence. When he showed "The Dead of Antietam" in October 1862, the *New York Times* said the photographs had the effect of "a few dripping bodies, fresh from the field, laid along the pavement."[34] Is this what Brady wanted, what the public wanted? Although the pictures were made by others, they came with the Brady imprimatur. "Let him who wishes to know what war is," wrote Oliver Wendell Holmes about the same pictures in the *Atlantic Monthly* in July 1863, "look at this series of illustrations" that "we owe to the enterprise of Mr. Brady of New York." Look, but don't look; the pictures are too much like being there; one can only treat them as "mutilated remains of the dead," "terrible mementos," and lock them securely away "in

[opposite]
open wound

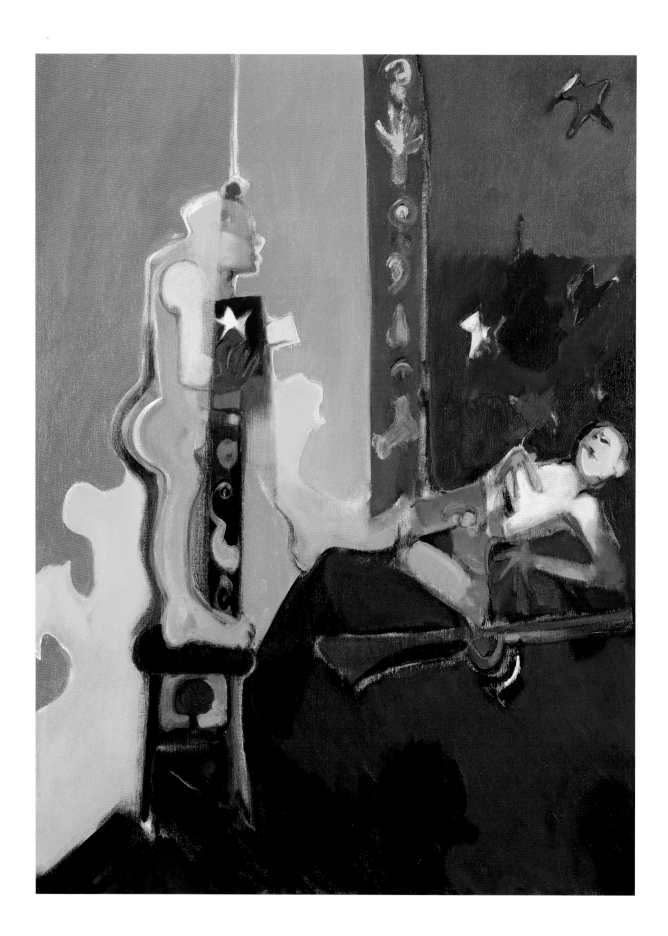

some secret drawer."[35] You want to see but you dare not. Better hide the horror in a pleasant landscape emptied of visible history and say "you are seeing what I am seeing"; I was already here, "I preceded you" (p. 177). In another watercolor: "this is Gettysburg . . . I emptied the battle site of painful detail and focused on melancholic contemplation" (p. 188).

Dragging corpses from place to place for the sake of "artistic effect," as we see in the magnificent *Arranging the Dead as a Work of Art* (opposite page), is another kind of mitigation. With great effect the painting exposes the hidden nerve that joins the antebellum portrait studio—already a gallery of the dead—and battlefield scenes composed as heroic acts of dying under starry night skies to ease the heart and tease the mind. Notably, the most famous of all Civil War battlefield photographs, "A Harvest of Death," taken by Timothy H. O'Sullivan at Gettysburg, aligns a corpse twisted into a slanted crucifix with a distant horse and rider who suggest death as the grim reaper. Allegory establishes a safe distance from the visceral horrors of such a harvest on a field of the Republic; allegory eases the heart.

Such killing fields were not mere incidents of war but the war itself: fields piled with what Phillips calls "refuse of war" (what's left behind, what's to be thrown away, swept out of sight) (p. 190) or, as he shows in *Landscape of Broken Parts at Chattanooga (November 24, 1863) (death is rarely random)*, bodies and parts congealed into a monstrous machine on wheels (p. 172). The latter painting shows Brady's camera recording the grisly sight; a huge hand with fingers spread reaches up for help or recognition, linking Phillips's powerful proleptic vision of mechanized violence to Picasso's *Guernica*. In Phillips's great battlefield sequence the Civil War presages the impersonal brutality of all modern warfare. We can see it already coming in the prophetic *civil war*, a green-nosed ogre of death with stars and bars and stripes (p. 168, left). The picture evokes Thucydides's *History of the Peloponnesian War*, with its dire account of the atrocities civil war brings forth. Americans in 1861 obviously gave his warning no heed.

The extent of the killing and the vast number of war-related deaths have alarmed many American historians as they struggle to decipher the meaning of such apparently unrestrained slaughter. Historian Drew Gilpin Faust describes Civil War battlefield scenes in images consistent with Phillips's series:

[opposite]
Arranging the Dead as a Work of Art, 2006
oil on canvas, 62 × 46 inches

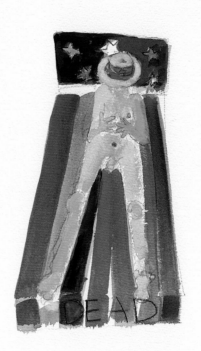

Men thrown by the hundreds into burial trenches; soldiers stripped of every identifying object before being abandoned on the field; bloated corpses hurried into hastily dug graves; nameless victims of dysentery or typhoid interred beside military hospitals; men blown to pieces by artillery shells; bodies hidden by woods or ravines, left to the depredations of hogs or wolves or time.[36]

The scale of the killing seemed justified if not actually encouraged by a "culture of death." Handlin's view of a country divided by pure hatred has been affirmed and revised by recent historians. Mark Schantz writes:

Americans of the antebellum era were well acquainted with death—both as a matter of demographics (average life expectancy was about forty years of age) and as matter of deep cultural reflection, evident in discourses on heaven, the emergence of the rural cemetery movement, in poetry and in literature, and in the arts. Americans brought to the Civil War a rich and sophisticated culture of death that made it both easier to kill and to be killed.[37]

Faust argues that battlefield corpses helped create the modern state with all its attendant impositions on private citizens. "Americans had not just lost the dead," Faust writes; "they had lost their own lives as they had understood them before the war."[38]

Experience of pain and infliction of pain, loss of body parts and of life in military service have been taken for granted ever since, regardless of the nature (aggressive or defensive) and location of the conflict. The Civil War inaugurated the era of standing modern armies, mass mobilization of financial, technological, and human resources for the sake of total destruction of "the enemy." The war empowered the modern bureaucratic state, made it seem a necessity simply to deal with so many bodies to be identified and buried with suitable recognition—national military cemeteries and the embalming of corpses were products of battlefield gore. Whitman's "lurid interiors" still inhabit the edges of national consciousness.

Whitman said those interiors were "inexpressible," and indeed the "inner civil war," the actual bodily experience of battle, has rarely appeared in American art or letters with credible exactness. Occasional epiphanies, insights into how it felt to be

[opposite]
civil war

DEAD

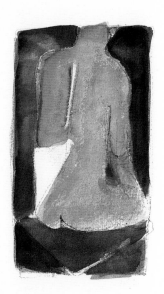

the person injured or slain, appear in Whitman's *Drum Taps*, a book of sharply etched impressions of camps and hospitals. In "Look Down Fair Moon" the perspective is safely distant and abstract, though an undercurrent of emotion without a name pulls the poem into an orbit of its own:

> LOOK down, fair moon, and bathe this scene;
> Pour softly down night's nimbus floods, on faces ghastly,
> swollen, purple;
> On the dead, on their backs, with their arms toss'd wide,
> Pour down your unstinted nimbus, sacred moon.[39]

The poet implores "fair moon" to "LOOK," to see "this scene" of "faces ghastly," and by looking to "bathe" or salve the swollen corpses, the look transmuted into "floods" of "nimbus," the cloud or halo surrounding a deity such as "sacred moon" (perhaps Artemis, perhaps Diana, perhaps the Egyptian Thoth). The poem transforms the moon into a feminine eye ("fair moon") that looks down, a look of recognition that represents salvation for broken bodies deprived of life—the secular salvation of being bathed in the cold uncanny light of the moon. They are sacrificial bodies, "their arms toss'd wide" in crucifix form, as in O'Sullivan's "A Harvest of Death." The corpses are beyond healing but the poem begs for a look—perhaps such as O'Sullivan gave at Gettysburg—to redeem these "faces ghastly, swollen, purple," a sign of recognition of the "mere likeness" of death.

John Phillips's revelatory battlefield paintings enact that look with an eye willing and able to see with compassion whatever is there. *Ransoming Mathew Brady* closes on a note of tragic acceptance of extremity: bloody death in fresh fields of green. Whitman would have recognized spiritual kinship here with his own "wound dresser": "An old man bending I come among new faces."[40] Whitman's poems and Phillips's battlefield paintings share a sense of having witnessed suffering bodies returned to receiving earth. The dominant note in both is the stillness of death and the freshness of new growth feeding on the dead. "If you want me again look for me under your boot-soles."[41] One after another, each keyed like Melville's

[opposite]
untitled

untitled

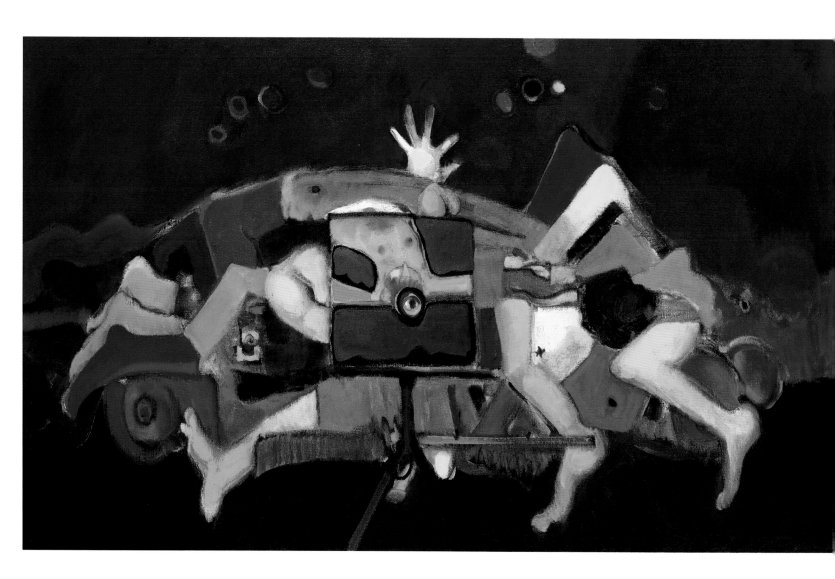

battle poems to a specific battle, each a literal aftermath of a literal event, the paintings march in order; they are the annals of war captured in a loving, accepting look.

In the battlefield paintings vision is the ultimate issue: how to see what refuses to be seen, refuses to surrender itself to the merely curious or merely documentary eye. There are no camera lenses depicted in this group of scenes—*Landscape of Broken Parts at Chattanooga* (opposite page) and perhaps *Broken Parts at Bloody Hills* (p. 207) are exceptions—but there are many eyes. The case for unrehearsed seeing is overwhelming, almost too much for a first-time viewer. *Parts and Smoke at Chickamauga (September 19, 1863)* (p. 231) catapults the viewer into comprehension. The "parts" along the edges right and left—an elbow, a hand—stand for a whole obscured by the blue smoke swirling and billowing into a mushroom cloud against a field of burning red. But being "parts"—the horror of speaking of the human body in such terms contributes to the effect—they tell us at the same time that there is no whole, only broken bodies, only scattered parts for that ghoulish green eye to look upon and finally to see. Seeing the war takes such an eye, not the fair moon pouring balm but an eye seared by war, a drop of blood-red in a black pupil floating in a green iris, an eye that outstares the viewer transfixed by the dazzling and dumbing blue nimbus that both entices and disturbs vision. The paintings include a bird's-eye view, a worm's-eye view, a "myopic close-up." Phillips's titles connect the paintings to the larger discourse of vision, in which tension between "exact likeness" and "arranged as a work of art" set the terms for these final incandescent canvases.

Phillips restores death to the dead: dismemberment, bullet hole in the middle of the forehead, body like a fallen trunk, the stunning death erection. Like Whitman's moon, Phillips pours the light of his paint to give the site and scene of death precise visibility; his paint salves and redeems by granting recognition. He makes seeing battlefield death for what it is—slaughter of innocents, speechless horror—the privileged work of his viewers. With one eye on the fair moon, the goddess of pure uninterrupted and untrammeled seeing, the other on the eye seared by war, vision becomes sacramental; we raise ourselves as we raise the dead. The process of ransoming Mathew Brady culminates in these paintings.

Here the camera image, its power of exactitude and unflinching seeing, fuses with Phillips's art of paint. Not "photo-realism," that ridiculous term, but paint revealing what lens and camera make possible though not sufficient in itself:

[opposite]
Landscape of Broken Parts at Chattanooga (November 24, 1863) (death is rarely random), 2007
oil on canvas, 40 × 65 inches

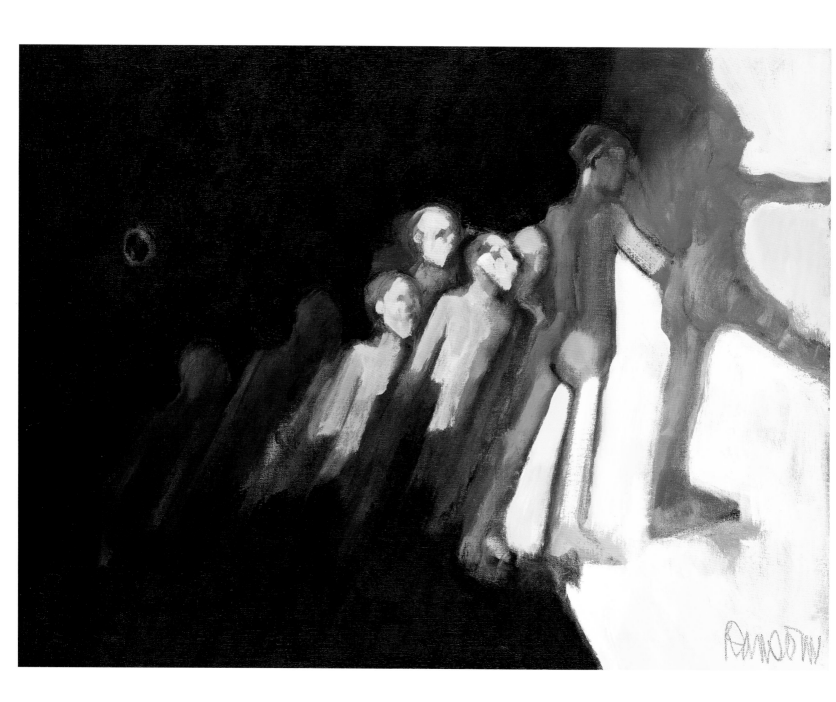

visions of the world as it is, not just in or to but also behind and beyond the eye, wherever the ransomed camera eye might take us. The ransom is accomplished, Mathew Brady liberated from the delusions of his gallery of Illustrious Americans, free now to accept "exact likeness" as exactly what suffices. There is a sense that what Phillips achieves in these battlefield scenes in glorious paint—fresh greens predominate—is also the work of the ransomed Mathew Brady.

Dance of Death at Appomattox (April 9, 1865) (opposite page) culminates the culmination. The dead are raised in this ecstatic vision, raised from the darkness on the left into light on the right, whole again as they always are in memory. The movement is an ascension, a sacral event, a mystic performance at the site of surrender—a reminder that the war did not end there, that the dead shall still be raised. The painting concludes the work in silence, no chords of heavenly music, no harmonies triumphant. But we might overhear some lines from Whitman in way of homage to the spirit of the entire work.

> And as to you Death, and you bitter hug of mortality,
> it is idle to try to alarm me. . . .
> And as to you Corpse I think you are good manure,
> but that does not offend me,
> I smell the white roses sweet-scented and growing,
> I reach to the leafy lips, I reach to the polish'd breasts
> of Melons.
> And as to you Life I reckon you are the leavings of
> many deaths,
> (No doubt I have died myself ten thousand times before.)[42]

Dance of Death depicts not conventional resurrection at Appomattox but the leavings of war coming to life again, offering themselves as the vital and necessary past lives of the nation. Not monumental memory in stone or ceremonial forgetting, not memory at all, really, but lurid interiors coming to life again in the artifice of light and paint.

[opposite]
Dance of Death at Appomattox (April 9, 1865), 2007
oil on canvas, 36 × 46 inches

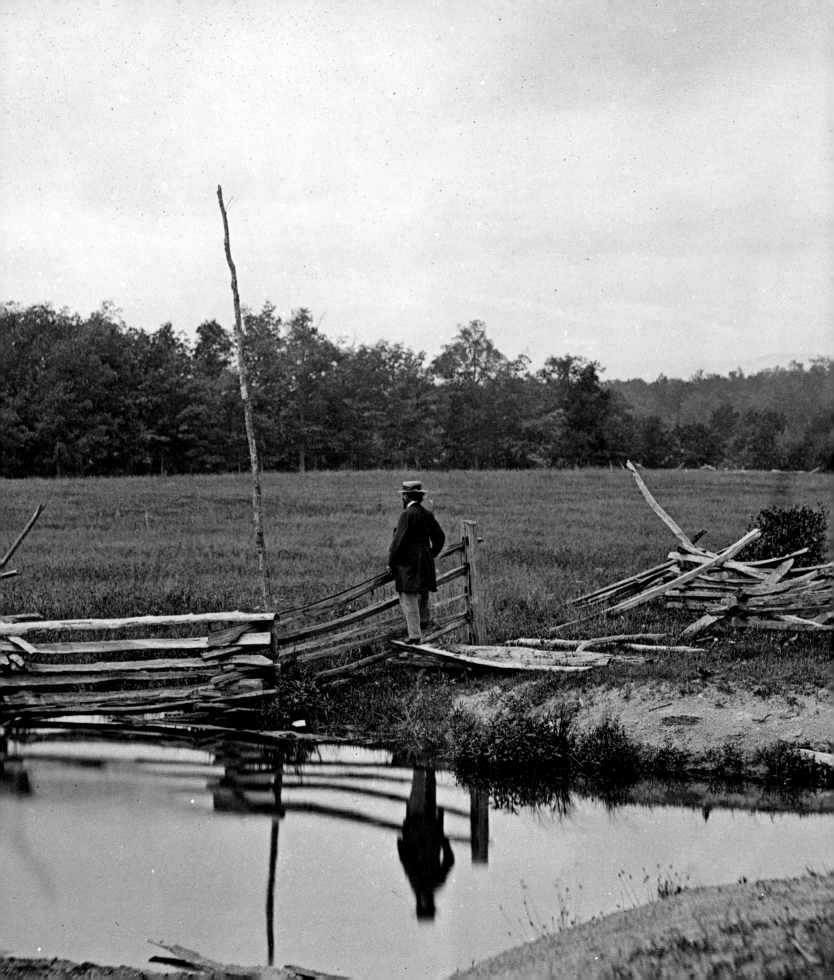

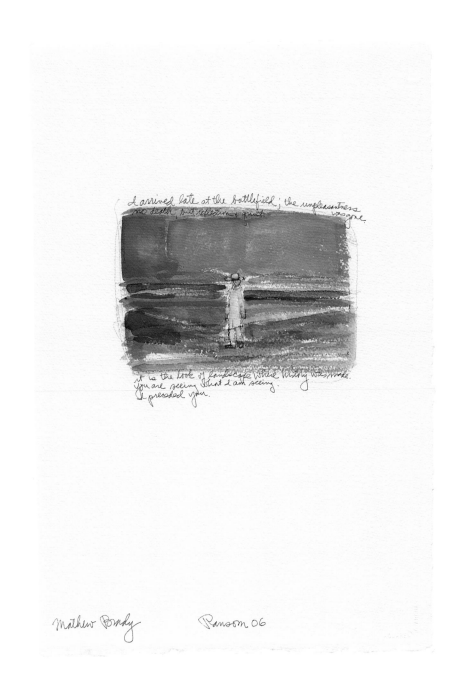

I arrived late at the battlefield; the unpleasantness was gone
no death, but reflection and quiet.
it is the look of landscape where history was made.
you are seeing what I am seeing.
I preceded you.

untitled

untitled

Mathew Brady Ransom 05

buried

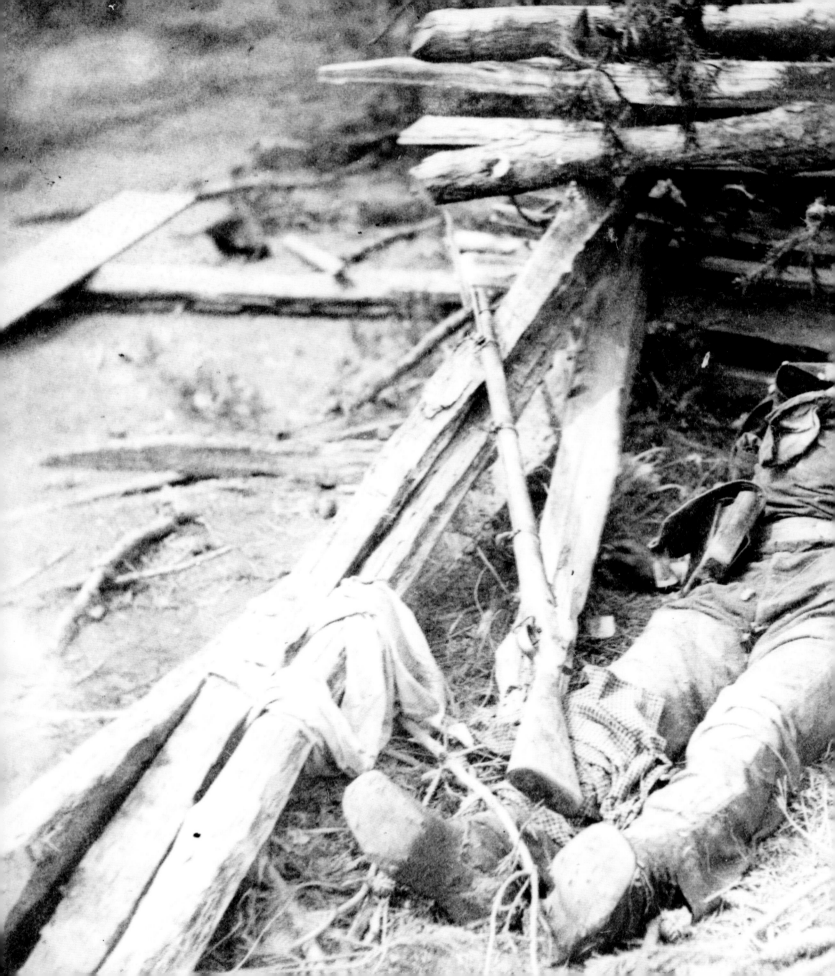

Mathew Brady Ransom 05

still life

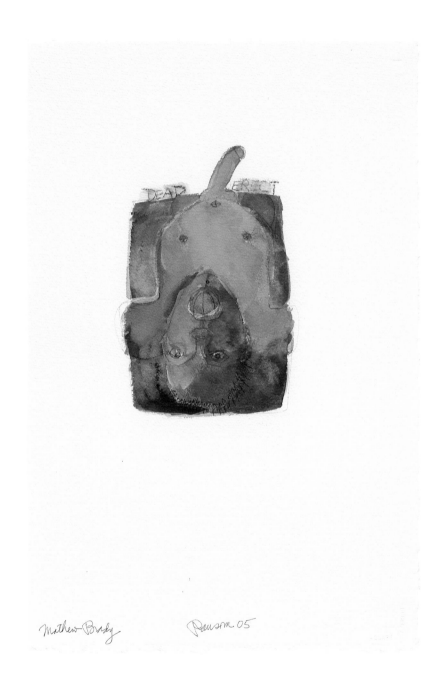

Mathew Brady Ransom 05

DEAD ERECT

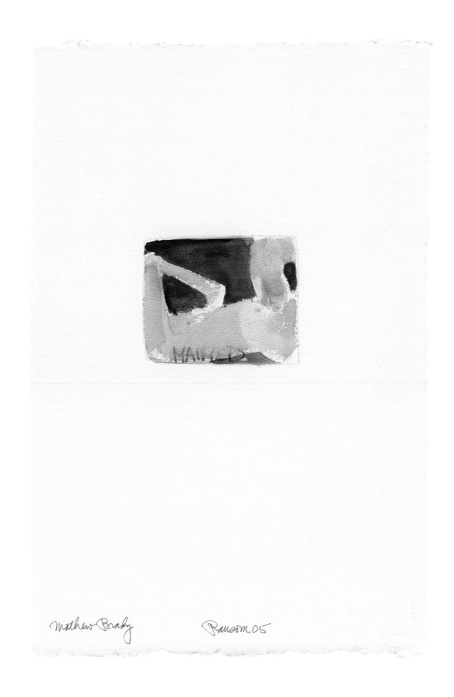

Mathew Brady Ransom 05

MAIMED

bandages become indelible

HANDS
of the
dead

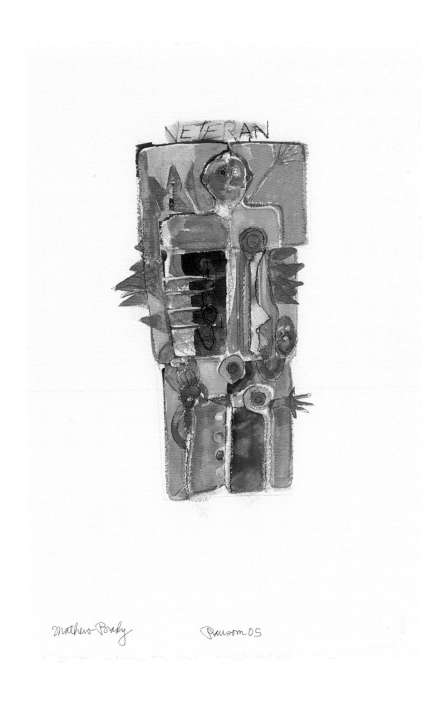

VETERAN

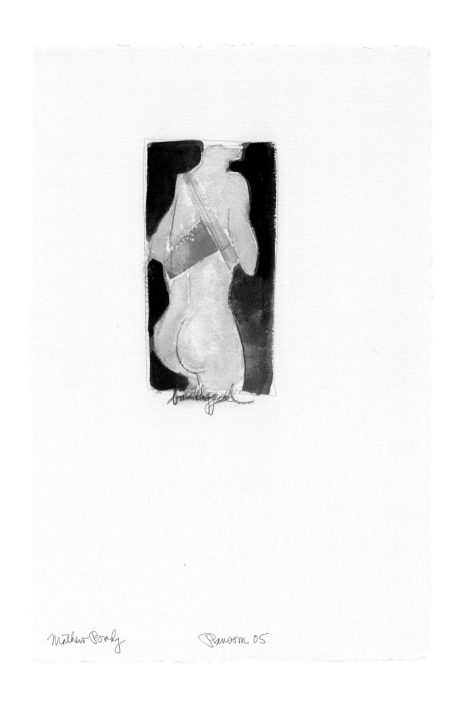

Mathew Brady Ransom 05

bandaged

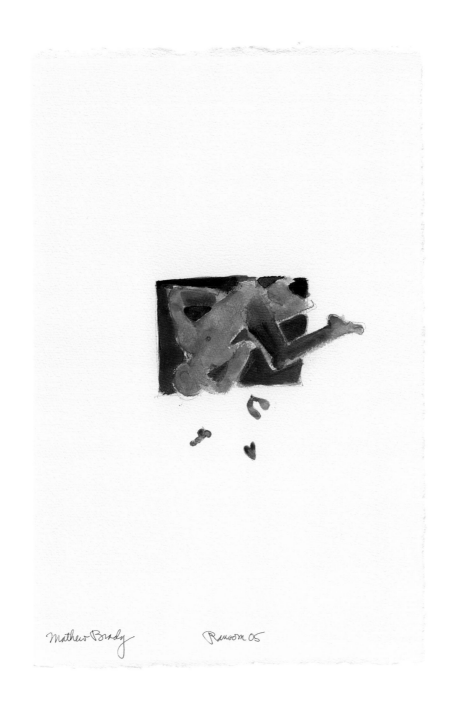

Mathew Brady Ransom 05

untitled

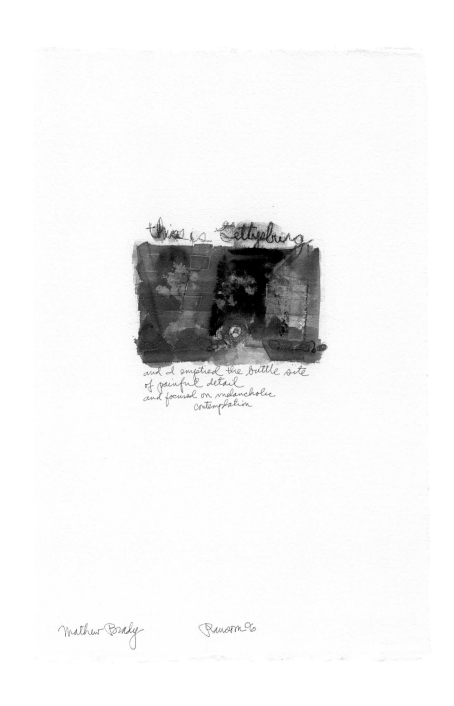

Mathew Brady Ransom 96

this is Gettysburg
and I emptied the battle site
of painful detail
and focused on melancholic
contemplation

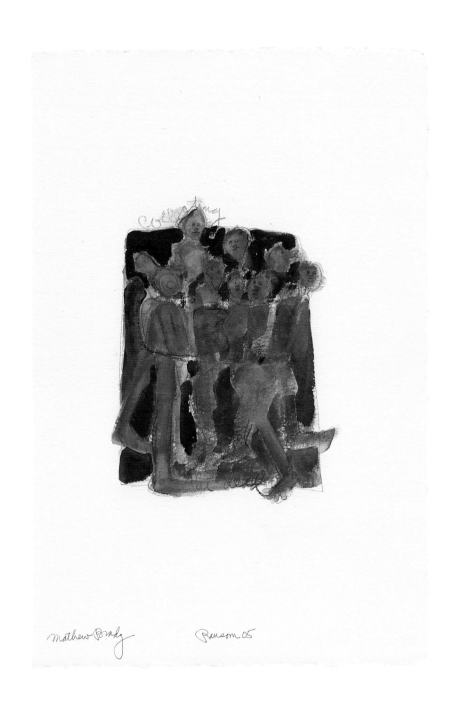

Mathew Brady Ransom 05

collecting
the dead

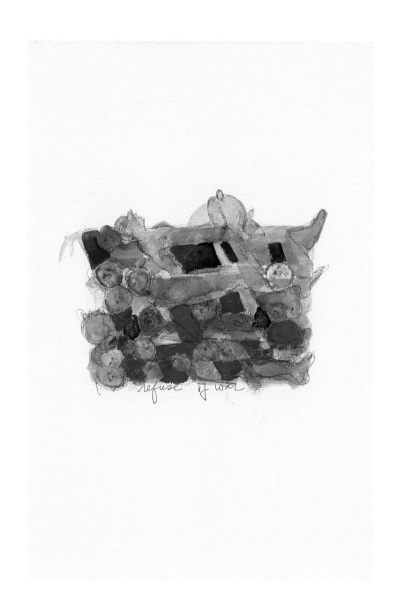

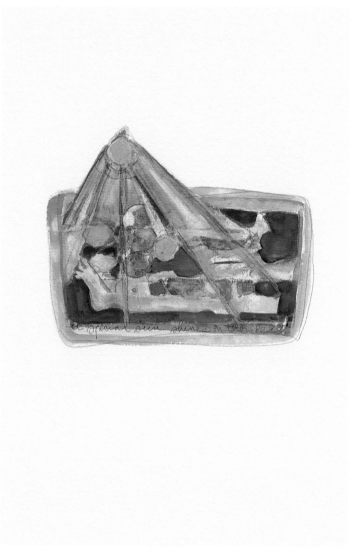

refuse of war

a special sun shines on the dead

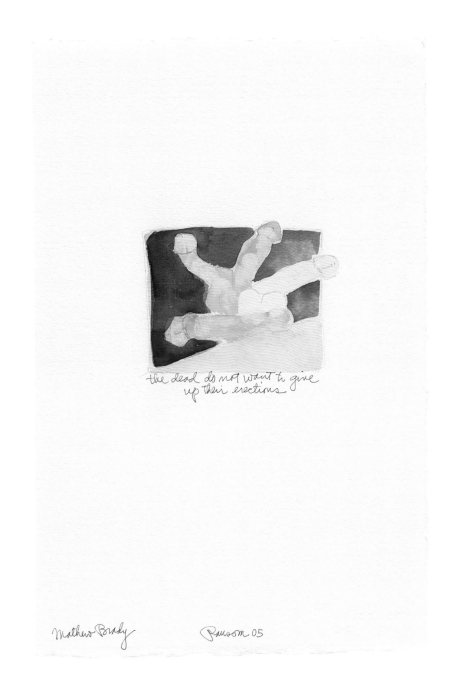

the dead do not want to give
up their erections

*the dead do not want to give
up their erections*

Mathew Brady Ransom 05

gallery of dead

untitled

AIM
AT
THE
HEART

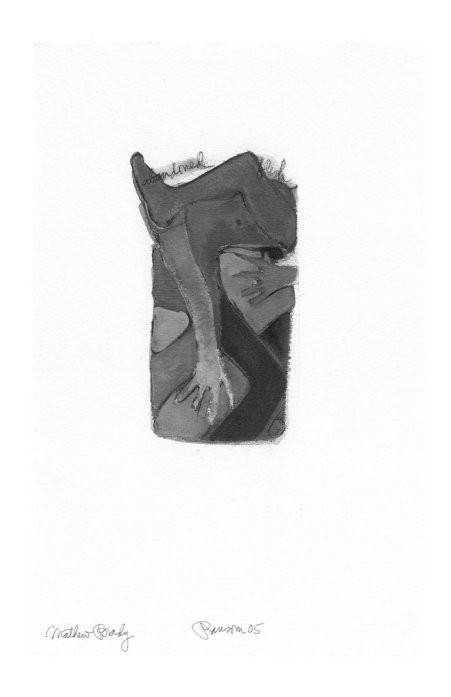

abandoned flesh

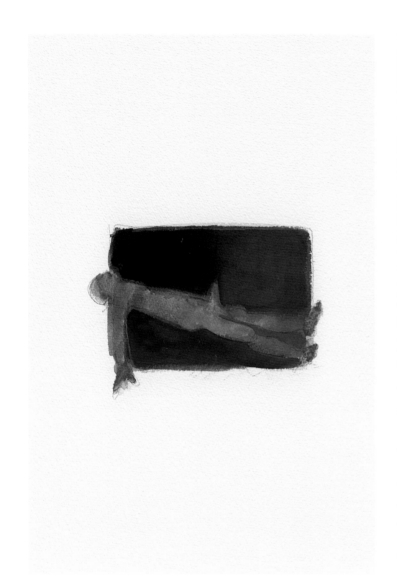

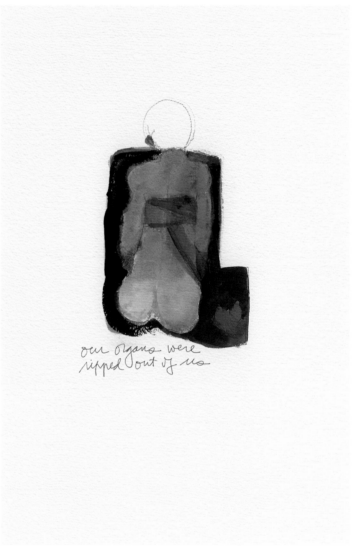

untitled

our organs were
ripped out of us

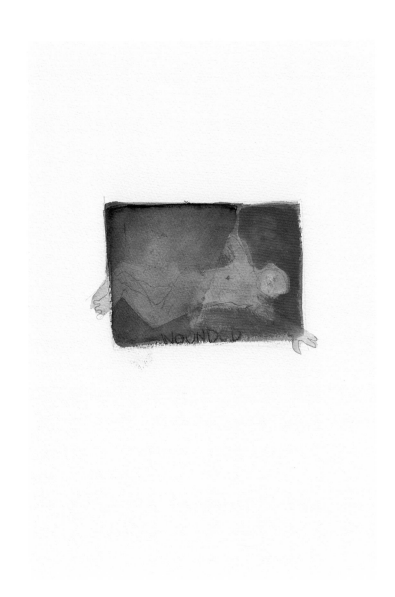

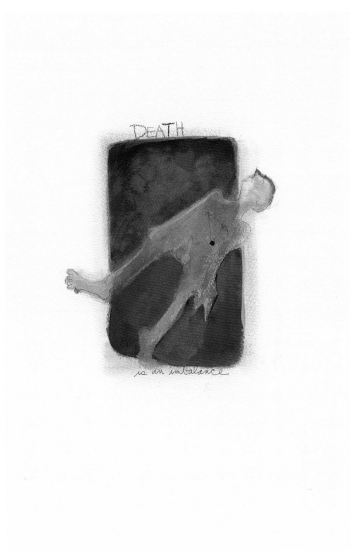

WOUNDED

DEATH
is an imbalance

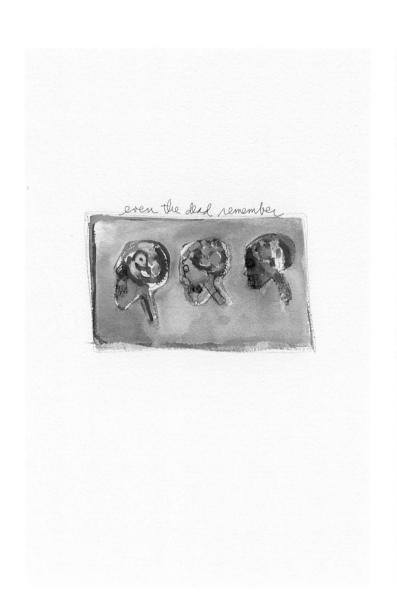

even the dead remember

discarded
hearts

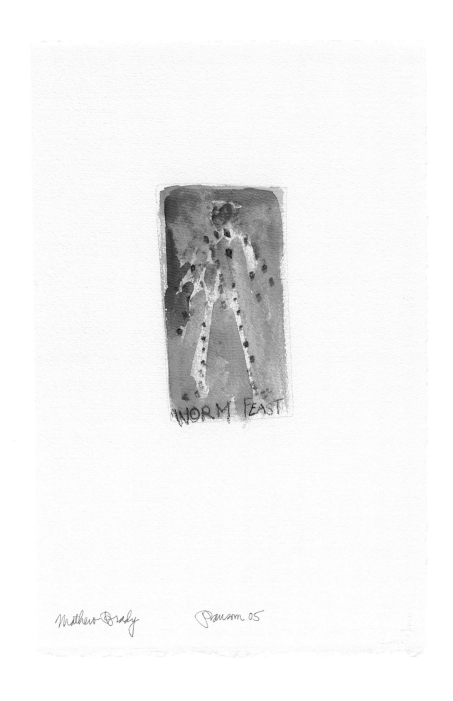

WORM FEAST

Shades, 2005
oil on canvas, 62 × 46 inches

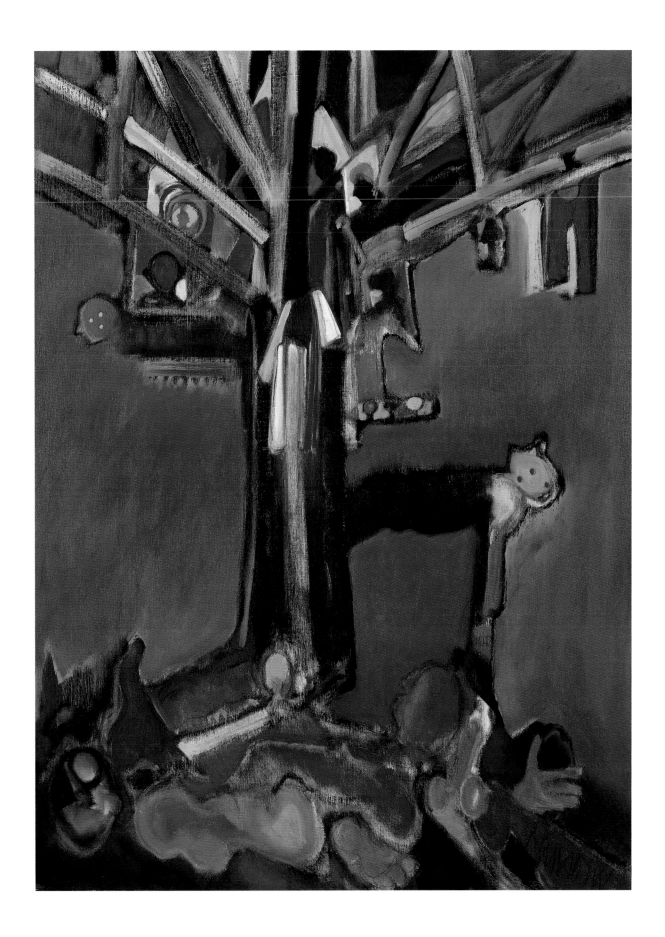

Worm's Eye View of Life and Burial at Bull Run (July 21, 1861), 2007
oil on canvas, 40 × 50 inches

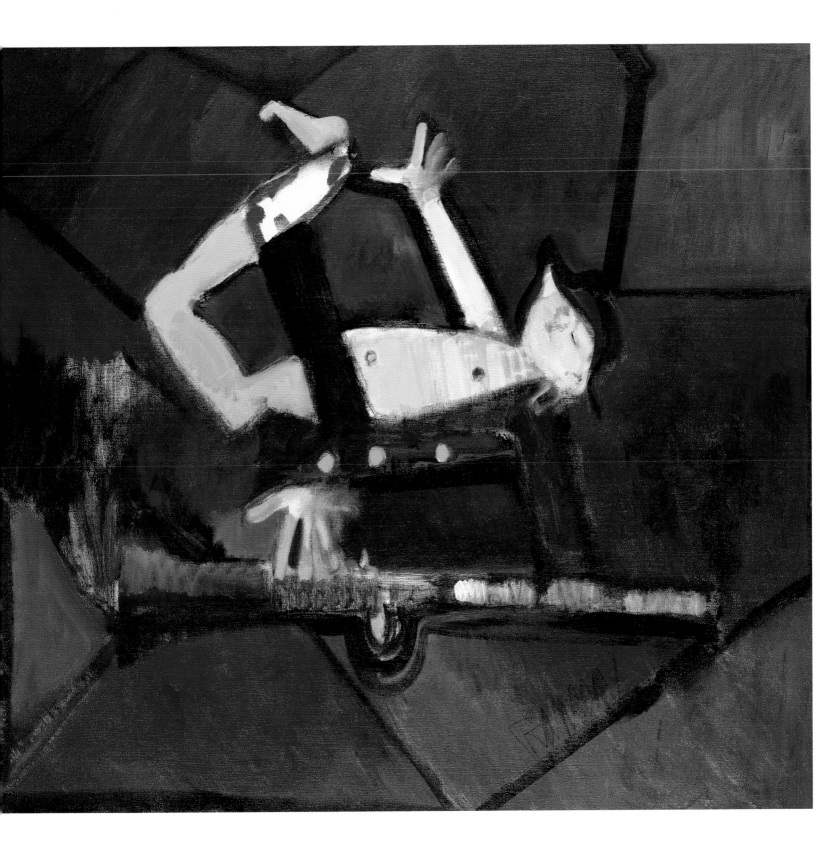

Broken Parts at Bloody Hill (August 10, 1861) (the dead have a configuration of their own), 2007
oil on canvas, 50 × 60 inches

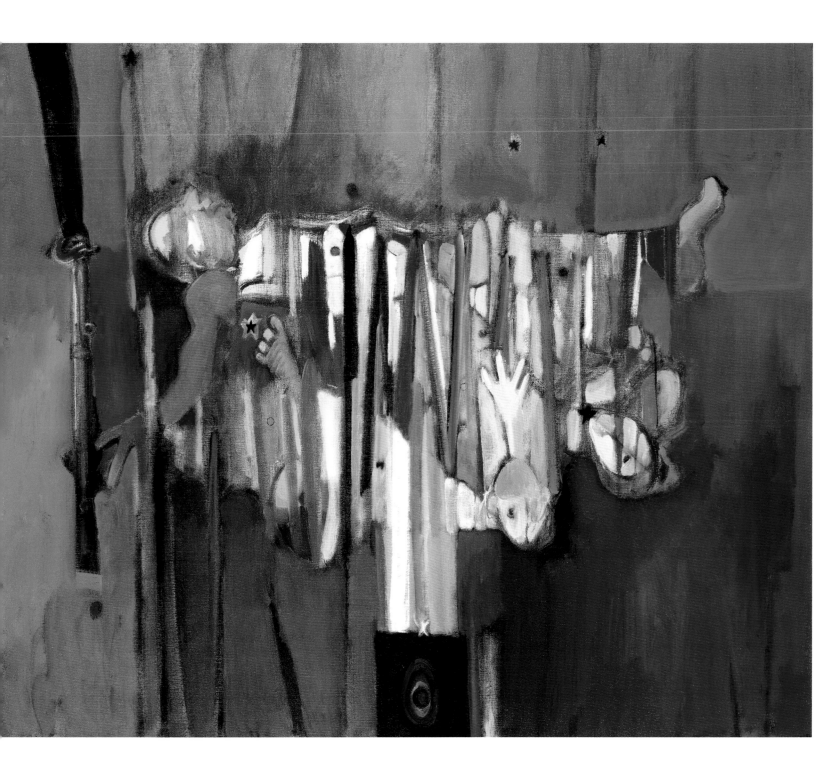

Struck Dead at Fort Donelson (February 13, 1862), 2007
oil on canvas, 16 × 20 inches

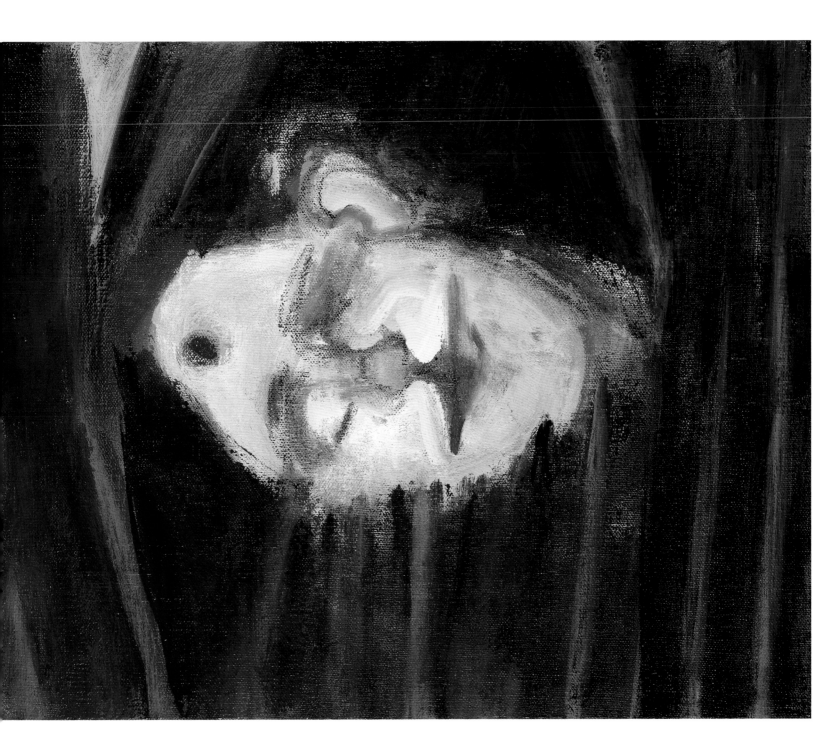

Abandoned Heart at Pea Ridge (March 7, 1862), 2007
oil on canvas, 16 × 20 inches

Fallen at Shiloh (April 6, 1862), 2007
oil on canvas, 46 × 62 inches

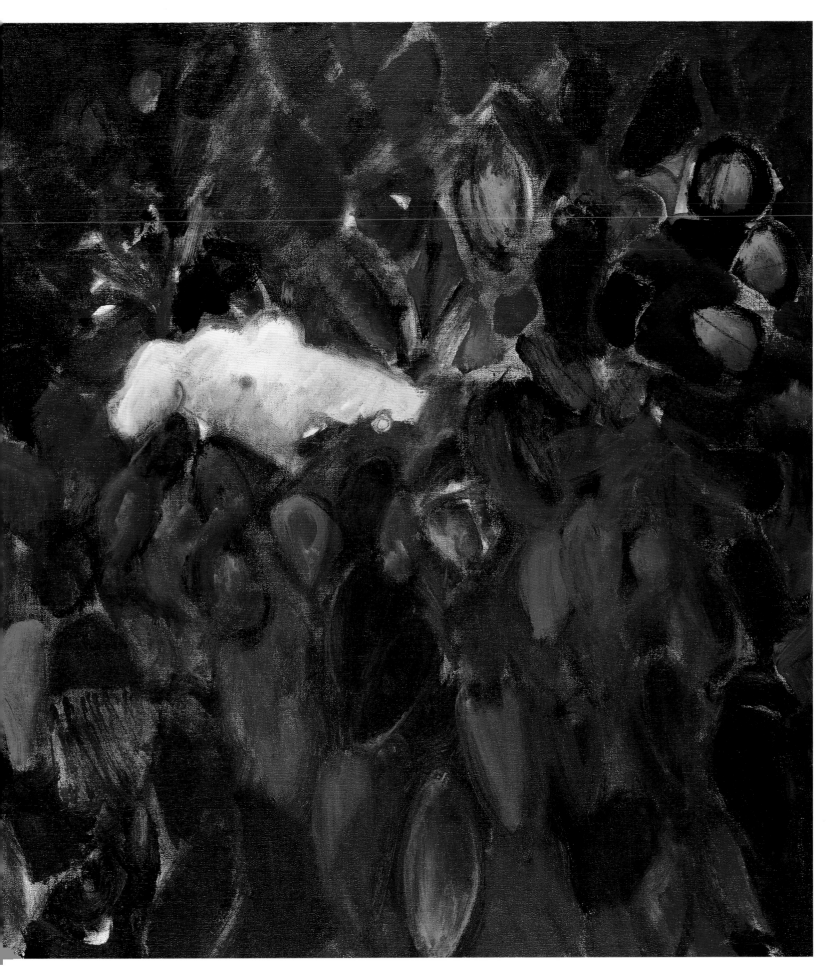

Death and Forgotten Selves at Second Manassas (August 30, 1862), 2007
oil on canvas, 40 × 50 inches

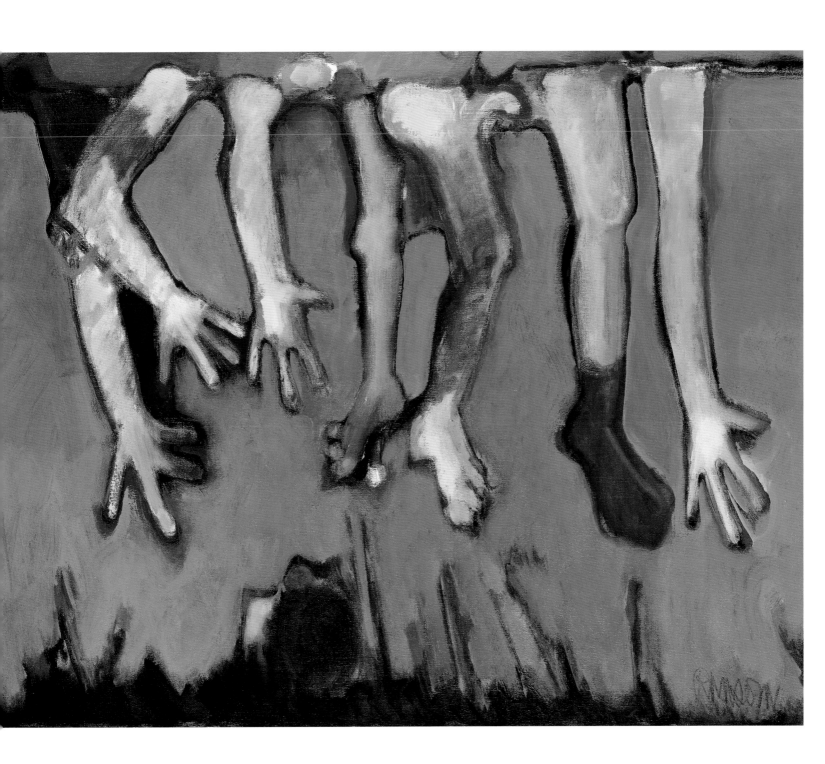

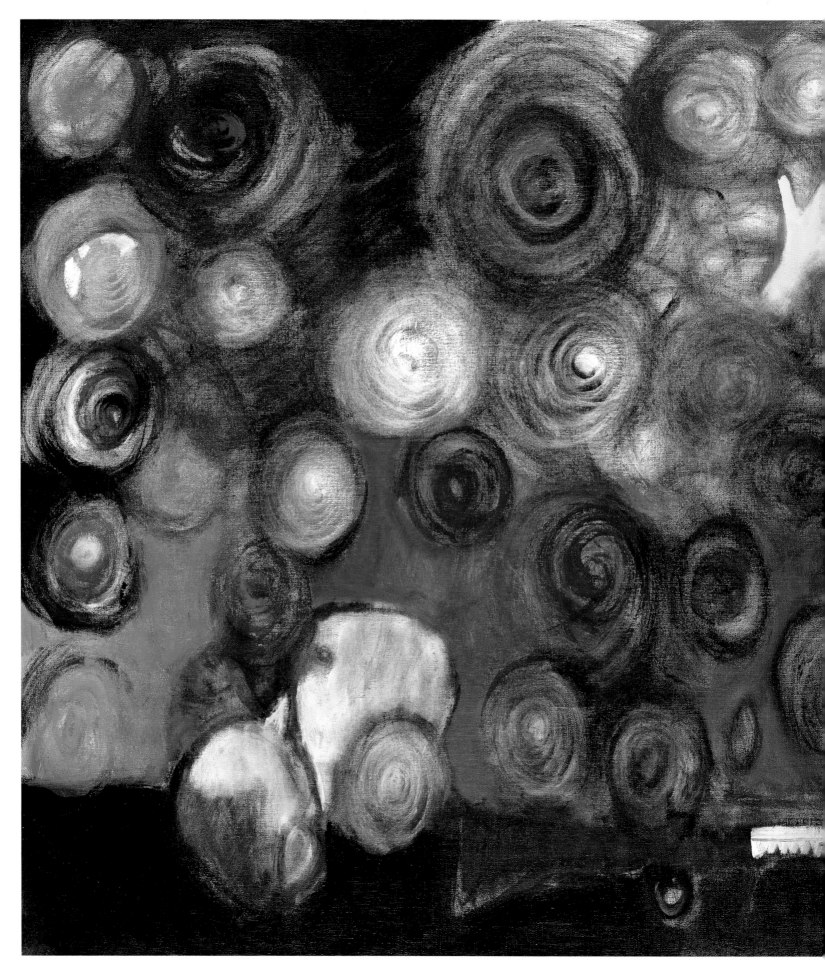

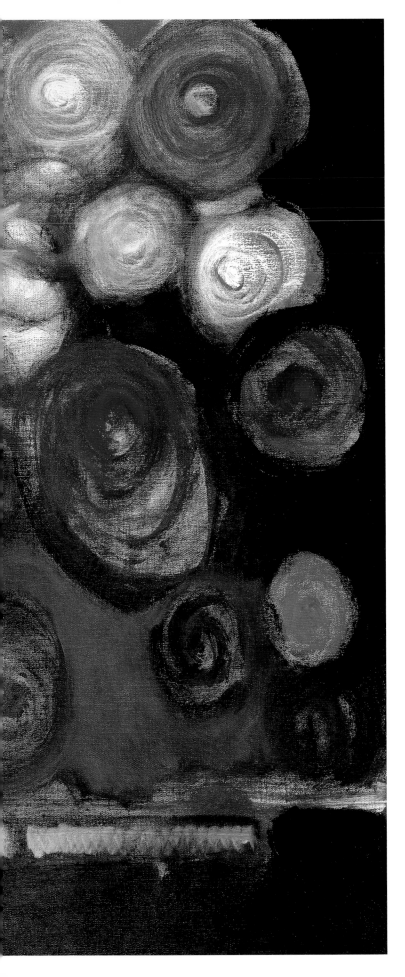

Antietam in Smoke (September 17, 1862), 2007
oil on canvas, 46 × 62 inches

Cannon Battery at Fredericksburg (December 13, 1862), 2007
oil on canvas, 44 × 48 inches

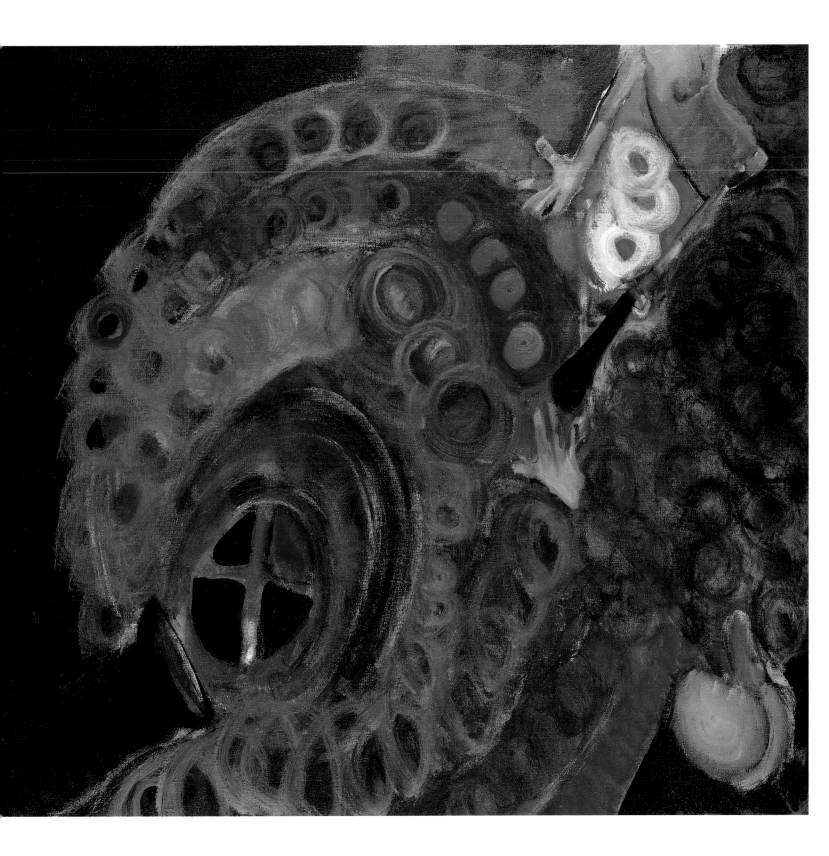

Scattered Parts at Murfreesboro (January 1, 1863), 2007
oil on canvas, 34 × 39 inches

Dead Erect: Chancellorsville (May 3, 1863), 2007
oil on canvas, 50 × 60 inches

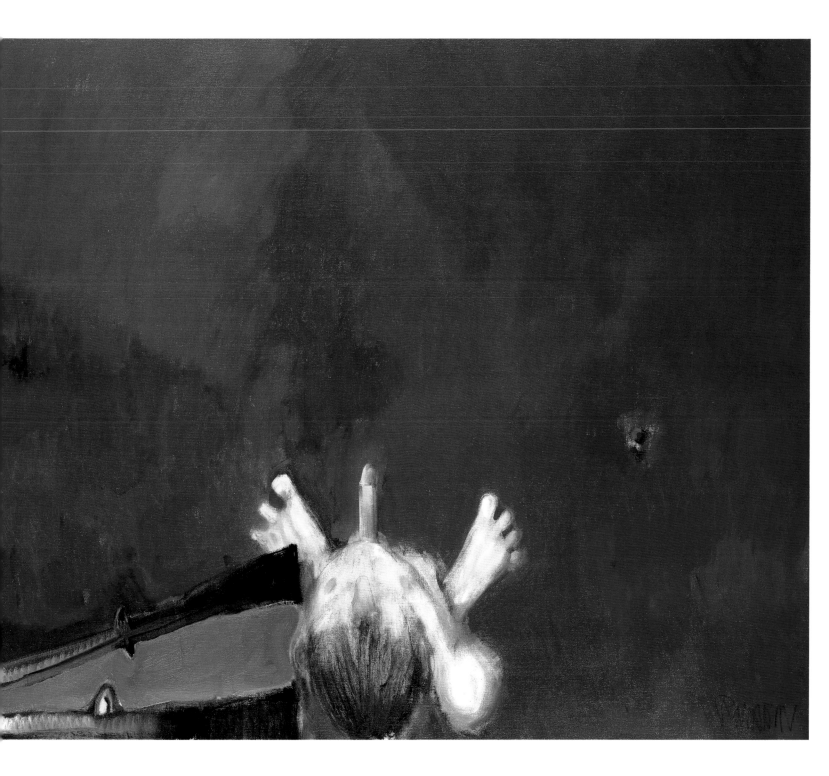

Bird's Eye View of Lost and Fallen: Chancellorsville (May 4, 1863), 2007
oil on canvas, 30 × 38 inches

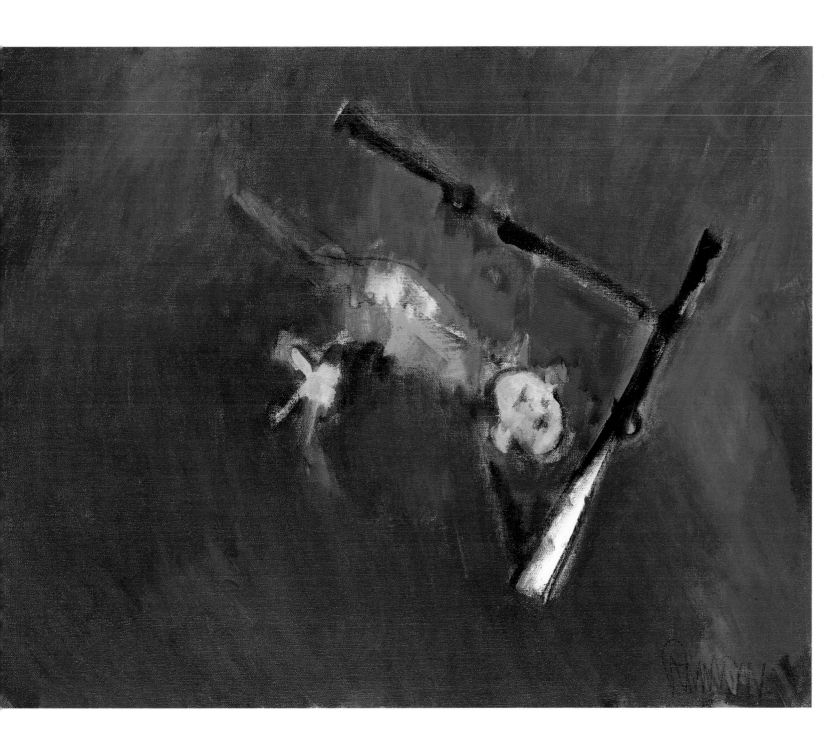

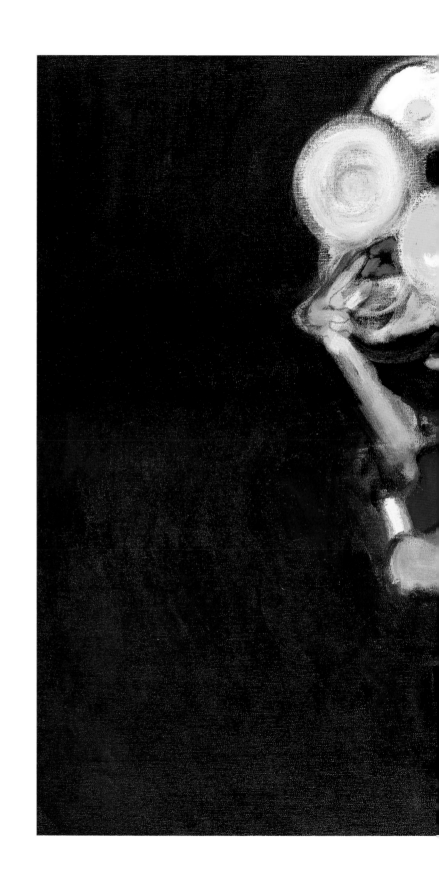

The Sun Shines Differently on the Dead at Vicksburg (July 1, 1863), 2007
oil on canvas, 40 × 65 inches

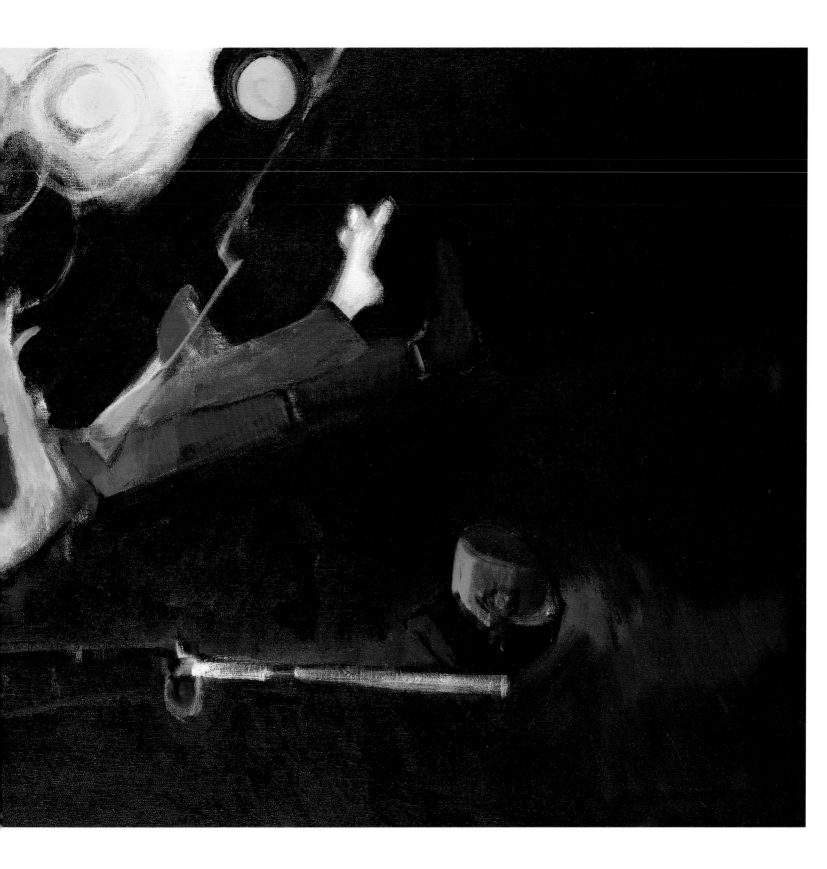

There Are Many Suns at Gettysburg (July 2, 1863), 2007
oil on canvas, 32 × 40 inches

Parts and Smoke at Chickamauga (September 19, 1863), 2007
oil on canvas, 20 × 30 inches

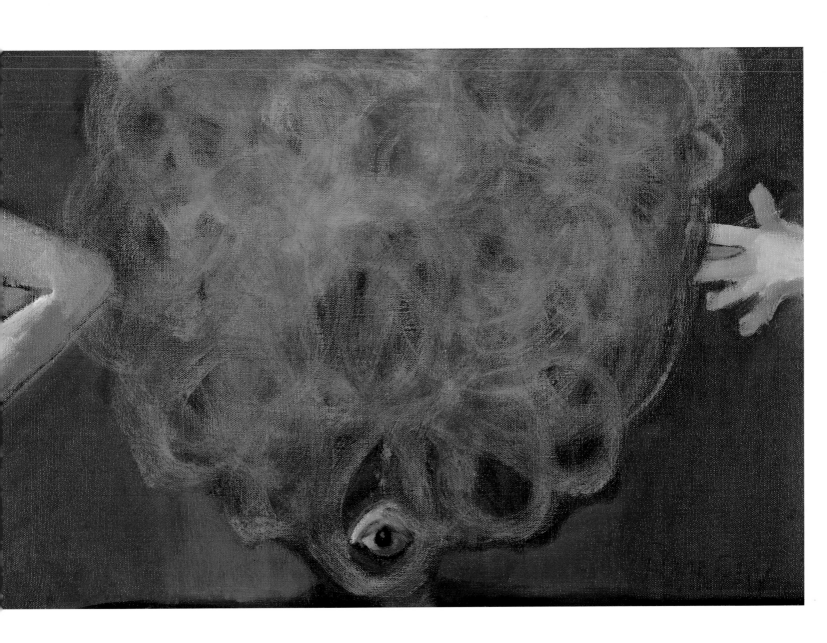

Myopic Close-up of Death at Chickamauga (September 20, 1863), 2007
oil on canvas, 40 × 50 inches

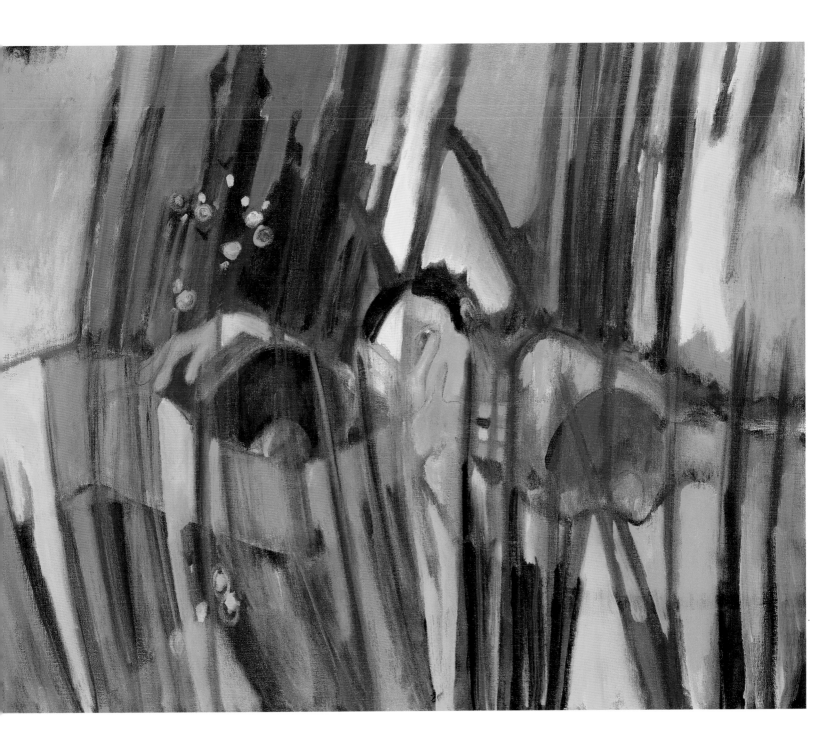

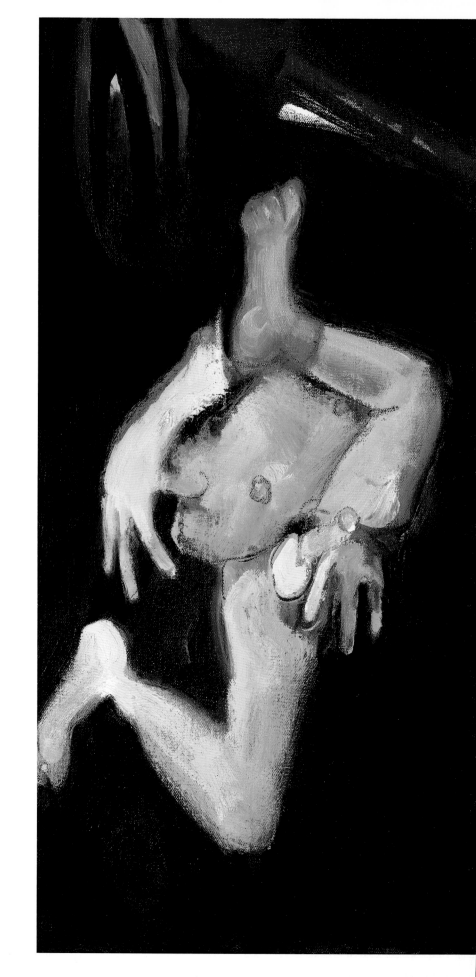

Choreographing the Dead at the Wilderness (May 6, 1864) (2 panels), 2007
oil on canvas, 30 × 35 inches overall

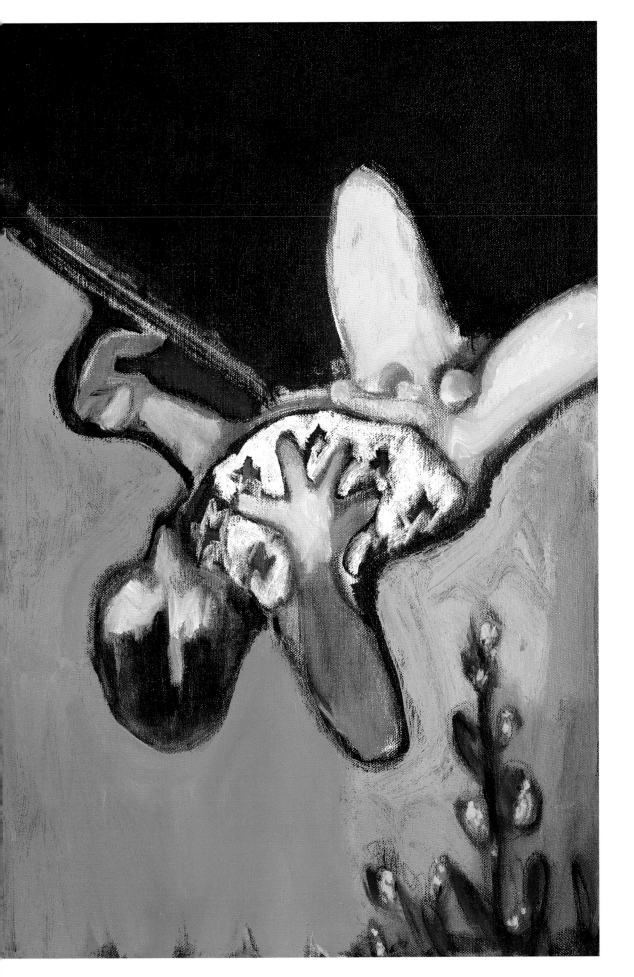

Heart and Hand Lost at Spotsylvania (May 19, 1864), 2007
oil on canvas, 20 × 22 inches

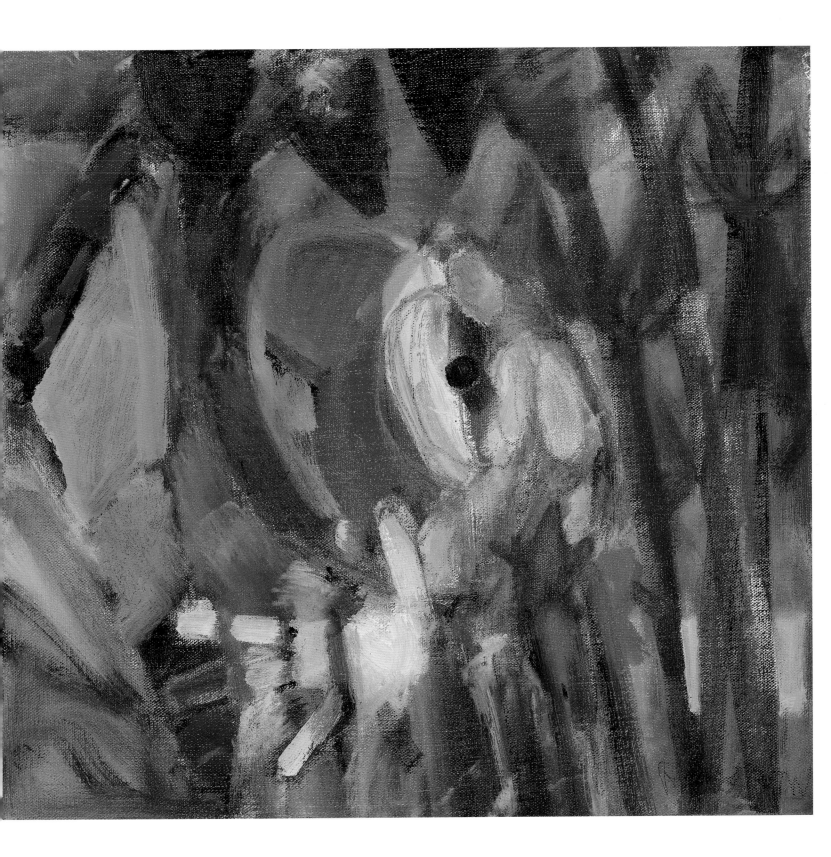

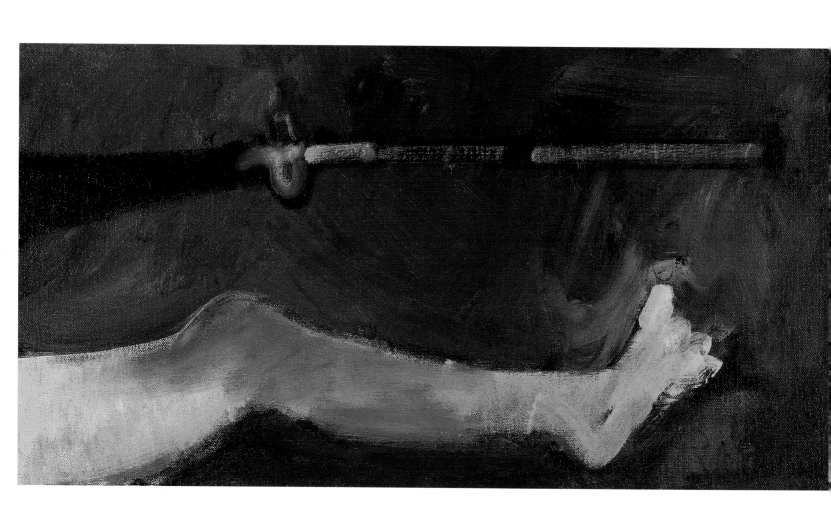

Still Life at Cold Harbor (June 3, 1864), 2007
oil on canvas, 16 × 30 inches

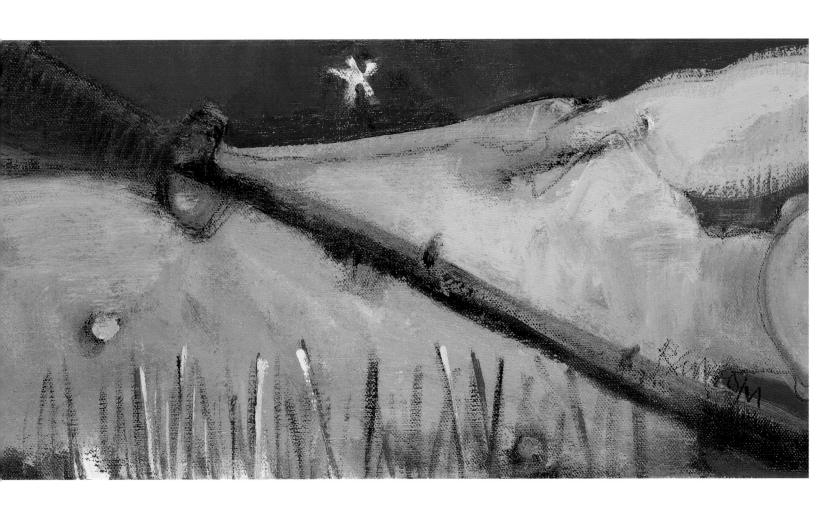

Fallen Trunk at Second Petersburg (June 15, 1864), 2007
oil on canvas, 10 × 20 inches

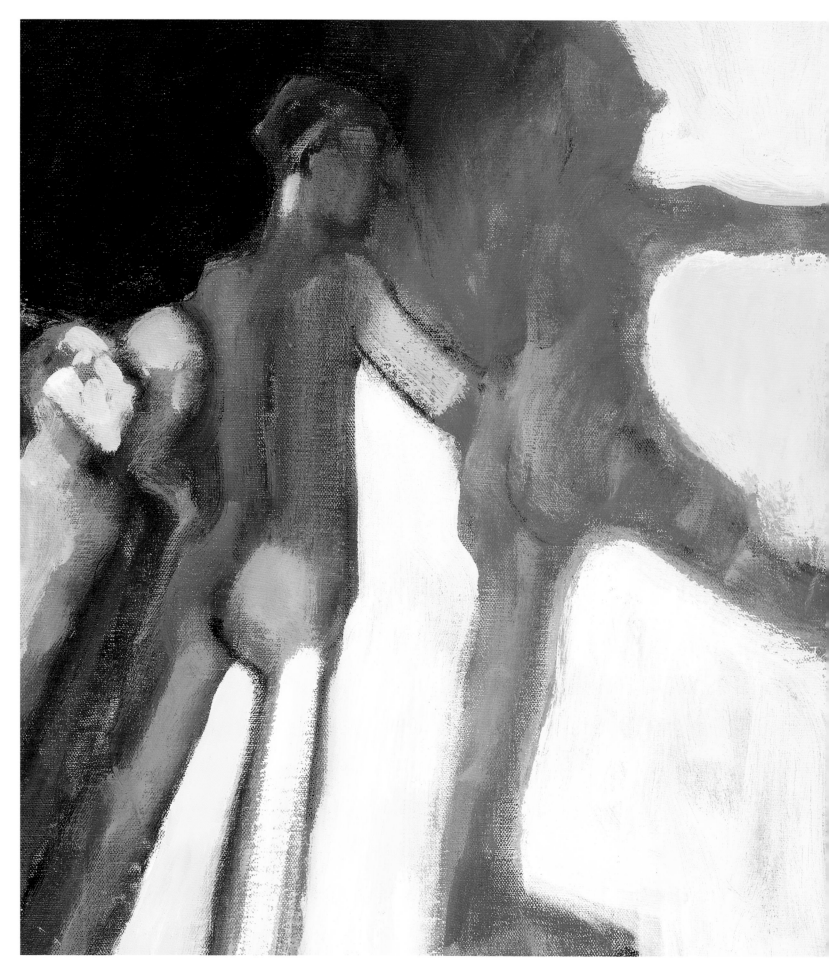

124. *A Sight in Camp*

Walt Whitman, *Leaves of Grass*

A SIGHT in camp in the day-break grey and dim,
As from my tent I emerge so early, sleepless,
As slow I walk in the cool fresh air, the path near by the hospital tent,
Three forms I see on stretchers lying, brought out there, untended lying,
Over each the blanket spread, ample brownish woollen blanket,
Grey and heavy blanket, folding, covering all.

Curious, I halt, and silent stand;
Then with light fingers I from the face of the nearest, the first, just lift the blanket:
Who are you, elderly man so gaunt and grim, with well-grey'd hair, and flesh all sunken about the eyes?
Who are you, my dear comrade?

Then to the second I step—And who are you, my child and darling?
Who are you, sweet boy, with cheeks yet blooming?

Then to the third—a face nor child, nor old, very calm, as of beautiful yellow-white ivory;
Young man, I think I know you—I think this face of yours is the face of the Christ himself;
Dead and divine, and brother of all, and here again he lies.

Dance of Death at Appomattox (April 9, 1865) [detail], 2007
oil on canvas, 36 × 46 inches

PHOTOGRAPHS

NOTES

1. See Alan Trachtenberg, *Reading American Photographs: Images as History, Mathew Brady to Walker Evans* (New York: Hill & Wang, 1989), especially Chapter 1, "Illustrious Americans." The best source for Brady's career in historical context is Mary Panzer, *Mathew Brady and the Image of History* (Washington, D.C.: Smithsonian Institution, 1997).

2. "I shall use the terms America and democracy as convertible terms." Walt Whitman, "Democratic Vistas," in *Whitman: Poetry and Prose*, ed. Justin Kaplan (New York: Library of America, 1982), 930. References to Whitman's writings cited in the text are to this edition.

3. For the cultural history of the daguerreotype in America the best study is Richard Rudisill, *Mirror Image: The Influence of the Daguerreotype on American Society* (Albuquerque: University of New Mexico Press, 1971). Also see Alan Trachtenberg, *Lincoln's Smile and Other Enigmas* (New York: Hill & Wang, 2006).

4. The best source for the artist's stylistic and conceptual intentions is "Emotional Ransom: Conversations with Ariel Orr Jordan," in John Ransom Phillips, *Bed as Autobiography: A Visual Exploration of John Ransom Phillips* (Chicago: Clarissa Editions, 2004), 69–135. See also Phillips's Web site, especially the artist's essay on the "Ransoming Mathew Brady" project, www.johnransomphillips.com/brady/intro.html.

5. Herman Melville, *The Confidence-Man: His Masquerade* (1857; repr. New York: Hendricks House, 1954), 271.

6. On the political and cultural crisis leading up to the Civil War, see David M. Potter, *The Impending Crisis, 1848–1861* (New York: Harper and Row, 1976), and George M. Frederickson, *The Inner Civil War: Northern Intellectuals and the Crisis of the Union* (New York: Harper & Row, 1965).

7. Kaplan, *Whitman: Poetry and Prose*, 27.

8. The classic study of the literary culture of the era is F. O. Matthiessen, *The American Renaissance: Art and Expression in the Age of Emerson and Whitman* (New York: Oxford University Press, 1941). Also see Harry Levin, *The Power of Blackness: Hawthorne, Poe, Melville* (New York: Faber & Faber, 1958). For discussion of literary responses to the war see Edmund Wilson, *Patriotic Gore: Studies in the Literature of the American Civil War* (New York: Oxford University Press, 1962).

9. Kaplan, *Whitman: Poetry and Prose*, 32.

10. Ibid., 88.

11. Ibid., 28–29.

12. Ibid., 27.

13. Kenneth T. Jackson, ed., *Empire City: New York Through the Centuries* (New York: Columbia University Press, 2002).

14. Quoted in "Suit Claims a Warhol Is Not, Well, a Warhol," *New York Times*, June 26, 2008, "Art & Design."

15. George A. Townsend, "Brady, the Grand Old Man of American Photography," *New York World*, April 12, 1891, 26.

16. Kaplan, *Whitman: Poetry and Prose*, 57.

17. Ibid., 51.

18. Horace Traubel, *With Walt Whitman in Camden* (1906; repr. New York: Rowman and Littlefield, Inc., 1961), 3:552–53.

19. Ibid.

20. For a persuasive discussion of the importance of ancient Egypt in Whitman's poems, see Stephen J. Tapscott, "Leaves of Myself: Whitman's Egypt in 'Song of Myself,'" *American Literature* 50, no. 1 (March 1978): 49–73.

21. Quoted in Trachtenberg, *Reading American Photographs*, 61.

22. Ibid.

23. Walt Whitman, *The Gathering of the Forces*, ed. Cleveland Rodgers and John Black (New York: G. P. Putnam's Sons, 1920), 2:113–17.

24. Quoted in Trachtenberg, *Reading American Photographs*, 43.

25. Ibid.

26. Alexis de Tocqueville, *Democracy in America* (1840; repr., New York: Vintage Books, 1945), 2:106.

27. A connection between photography and death is a major motif in Roland Barthes, *Camera Lucida: Reflections on Photography* (New York: Hill & Wang, 1982). For example: "In front of the photograph of my mother as a child, I tell myself: she is going to die: I shudder, like Winnicott's psychotic patient, over a catastrophe which has already occurred. Whether or not the subject is already dead, every photograph is this catastrophe." Ibid., 96.

28. Richard McKeon, ed., "De Poetica," in *The Basic Works of Aristotle* (New York: Random House, 1941), 1455–59.

29. Plato, "Art and Illusion," in *The Republic* (H. D. P. Lee, ed., Baltimore: Penguin Books, 1961), 370–79.

30. Herman Melville, *Poems of Herman Melville*, ed. Douglas Robillard (New Haven: College & University Press, 1976), 39.

31. Kaplan, *Whitman: Poetry and Prose*, 778–79.

32. Oscar Handlin, "The Civil War as Symbol and as Actuality," *Massachusetts Review* 3 (Autumn 1961): 135.

33. Quoted in Trachtenberg, *Reading American Photographs*, 71–72.

34. "Brady's Photographs: Pictures of the Dead at Antietam," *New York Times*, October 20, 1862.

35. Oliver Wendell Holmes, "Doings of the Sunbeam," *Atlantic Monthly* (July 1863): 11–12.

36. Drew Gilpin Faust, *This Republic of Suffering: Death and the American Civil War* (New York: Knopf, 2008), quoted by Jon Wiener, *Los Angeles Times*, January 6, 2008, R-3.

37. Mark S. Schantz, "How Americans in the Civil War Dealt with Death: One Historian's View," *History News Network*, http://hnn.us/articles/50196.html. Also see Schantz, *Awaiting the Heavenly Country: The Civil War and America's Culture of Death* (Ithaca, NY: Cornell University Press, 2008).

38. Faust, *This Republic of Suffering*, quoted in James M. McPherson, "Dark Victories," *New York Review of Books* 35, no. 6 (April 17, 2008): 78–79.

39. Kaplan, *Whitman: Poetry and Prose*, 453.

40. Ibid., 442.

41. Ibid., 247.

42. Ibid., 85–86.